WILLIAM HENRY JERNAGIN
in WASHINGTON, D.C.

Faith in the Fight
for Civil Rights

IDA E. JONES, PhD

THE
History
PRESS

Published by The History Press
Charleston, SC
www.historypress.net

Front cover: William Henry Jernagin portrait. *Courtesy of the Mount Carmel Baptist Church Archives.*
Back cover, top: Members of the Social Action Committee of Mount Carmel Baptist Church.
Courtesy of the Mount Carmel Baptist Church Archives.
Back cover, bottom: Jernagin, Mary Church Terrell, R.L. Patterson and others protesting.
Courtesy of the Moorland Spingarn Research Center.

First published 2016

ISBN 978.1.5402.0311.3

Library of Congress Control Number: 2015959413

Notice: The information in this book is true and complete to the best of our knowledge. It is
offered without guarantee on the part of the author or The History Press. The author and
The History Press disclaim all liability in connection with the use of this book.

Dedicated to Yolanda Williams for the love of archives, history and Mount Carmel Baptist Church.

Contents

CONTENTS

FOREWORD

Once in a generation, a person comes along who endeavors to change the way people view themselves and the world, in part because of the way God has wired mankind and in part from the demands of social pressures, political issues and crusades for justice/fair play. A lot of the time, these people, these agents of change, are often unsung or unknown to the mainstream after their mortal time on earth. Dr. William Henry Jernagin was such a person. As an ordained Baptist preacher, prophet, religious leader and civil rights advocate, his fingerprints are evident in many of the transforming events that led to the modern civil rights movement contemporary to the human rights movement. Jernagin created and sustained institutions that greatly improved and enhanced the lives of mankind in general, and the Negro in particular, along local, regional, national and international lines. This study brings to light Dr. Jernagin's life's ambition, which was to enable his people with God's guidance and assistance to reach their fullest potential, occupying the upper echelons of society, all the while maintaining and preserving their own culture as men and brother, citizen and patriot in America and abroad.

I am both privileged and honored to say a few words about a man whom I never met, who died long before I was born, yet my life has and continues to be lived out essentially according to his vision. While attending Howard University as a graduate student in the Department of History, I decided that I would write my master's thesis on my grandfather, Dr. Andrew Fowler. Prior to this, while I was an undergraduate student at the University of

the District of Columbia, my father had given my grandfather's papers to Moorland-Spingarn Research Center, which is housed on Howard's campus. When Dr. Ida E. Jones and the staff at Moorland-Spingarn delivered box after box and copy after copy for me, I immersed myself in the life of my grandfather—a small-town country boy from Inman, South Carolina, who arrived in Washington, D.C., on August 13, 1937, to attend the School of Religion at Howard University, having graduated from Tuskegee Institute two months earlier. I rediscovered that during his early years at Howard and at his apprenticeship at the historic Shiloh Baptist Church before being called to pastor the Capital View Baptist Church in the northeast quadrant of the city, he became closely acquainted with Baptist "giants" like Mordecai Wyatt Johnson, president of Howard University; Benjamin Elijah Mays, dean of the School of Religion at Howard University and president of Morehouse College; Howard Thurman, founding dean/chaplain at Rankin Chapel of Howard University; Earl L. Harrison, pastor of Shiloh Baptist Church and innovative leader; John Lawrence Sullivan Holloman, pastor of Second Baptist Church; Mary Church Terrell, club woman and activist; Nannie Helen Burroughs, school founder and Baptist Women's Department activist; *and* Dr. Jernagin.

My grandfather, Andrew Fowler, earned advanced degrees and had sat under some of the greatest minds. Initially, he was what was known as a satchel man. In layman's terms, he was Dr. Jernagin's adjutant; in modern church terms, he was the armor bearer. For the last fifteen or so years of Jernagin's life, where you saw one, you generally saw the other. As I delved into my grandfather's life and involvement in Baptist and ecumenical activities and civil rights issues, particularly as it relates to the District of Columbia, I realized that without the tutelage and mentorship of Dr. Jernagin, he would not have become what he essentially became—a man of causes.

In this book, Dr. Jones uses multiple approaches for inquiry by focusing on Dr. Jernagin's organizational involvement, educational programming and political activities to address not only the segregation and discriminatory practices and policies that loomed over American society but also the religious interdenominational and theological ideologies that existed among preachers of the Gospel. Jernagin was in a key position to organize and communicate the concerns of African American clergy and laity. His vision and interests made a deep impression on my grandfather and other young pastors and ministers who had a concern for cooperative religious work, with my grandfather catching some of his enthusiasm for cooperative action by, from and on behalf of the Negro churches.

In addition to a full-time pastorate at the historic Mount Carmel Baptist Church, Dr. Jernagin served as the president of the General Baptist Convention of the District of Columbia and president of the National Baptist Congress Sunday School and Baptist Training Union, while also finding the time to establish the Washington Baptist Theological Seminary in 1926. Another very important organization to which he belonged was the National Fraternal Council of Negro Churches of America, Incorporated (NFCNC), of which he served as chairman and founder of the Washington Bureau, as well as its action arm—the Committee of One Hundred Ministers. Dr. Jernagin's contributions as a "Chaplain for Christ and the Race" outside the United States are also central to this book. His involvement with W.E.B. DuBois and the Pan-African Congress showcases his commitment to end colonial rule, racial discrimination and imperialism in Africa and the Caribbean, while also demanding basic human rights and equality of economic opportunity.

Until the day my grandfather died in early 2003, he regularly spoke the name of Dr. William Henry Jernagin. Dr. Jernagin, though small in stature, was a giant in spirit and a possessor of phenomenal insight. He obviously believed in and practiced what the scripture says:

> *Write the vision, and make it plain upon tables, that he may run that readeth it. For the vision is yet for an appointed time, but at the end it shall speak, and not lie: though it tarry, wait for it; because it will surely come, it will not tarry.*
>
> *—Habakkuk 2:2–3, KJV*

And having envisioned it, he had the tenacity, fortitude and perseverance to see it through to manifestation. He was a man of uncommon valor, vision and foresight who had an uncanny ability to read people and situations; a man of great patience and determination who knew where he was going and relied on the Holy Spirit to lead him to where He would have him go, able to separate the wheat from the chaff. He was ever moving onward, not allowing circumstances and appearances to slow him down or dissuade him. He was always a great motivator, always seeking new challenges as he endeavored to promote the interests of his people. He lived as though God was watching his every move, as though he expected Jesus to return any day and request of him, "Give an account of thy stewardship." He knew with God on your side, the whole world against you will not stand. These principles of life

he instilled in my grandfather, and my grandfather instilled them in my father, and my father is endeavoring to instill them in me. The spirit of Dr. William Henry Jernagin has impacted my professional life in many ways as well, as I strive to do whatever I do with excellence and integrity. He was a man of great character who believed that character builds the person, character builds the family and character builds the nation. The scripture says, "Righteousness exalteth a nation: but sin is a reproach to any people" (Proverbs 14:34, KJV).

JOHN T. FOWLER II, MA
Historian,
Capital View Baptist Church, Washington, D.C.

PREFACE

L. Venchael Booth, founding publisher of the *Nation's Prayer Call*, wrote:

> *Dr. Jernagin is a Faithful Christian. His illustrious life reveals his determination to be faithful to the end. He does not stand in the way of anyone. He simply takes his place and keeps moving ahead. Anyone who catches his vision may follow in his train. He was among the first to recognize the heroic and courageous leadership of Dr. Martin Luther King, Jr. of Montgomery Alabama's famed Bus Boycott Movement and the first to offer assistance. There is no tendency on his part to block the roadway. He simply moves ahead as one determined to do a day's work. He takes no credit unto himself for the length of that day, nor does he blame anyone that it has been so long.*[1]

Booth and a coterie of then-young Baptist ministers and thirty-three delegates from fourteen states eventually struck out from the National Baptist Convention and formed their own fellowship, the Progressive National Baptist Convention (PNBC). Populated with energetic, younger and passionate voices, the men and women who composed the PNBC believed in the transformative power of Jesus Christ, social justice and truth.

According to the PNBC website:

> *The formation of the convention was wrapped up in the Civil Rights movement and was begun by some of the same persons who were deeply*

involved in the freedom movement for African Americans in the United States. From a religious perspective, churches from across the United States were suffering from an identity crisis fostered by racism, and conservative political policies and practices that supported segregation and U.S. apartheid. Theologians, seminary students and religious leaders were now openly questioning theological constructs and historical assumptions that were the basis for doctrinal practices that supported two societies in America: one White and the other Black.[2]

The PNBC became a new Christian movement that included an array of social and political concerns embodied in its founding principles of fellowship, progress, service and peace. The PNBC movement supported Dr. Martin Luther King Jr.'s struggle for freedom for African Americans. It was the PNBC that provided a denominational home for King and many of the Baptist leaders in the civil rights movement. They all became important forces in the life and work of the Progressive National Baptist Convention, Inc.

The convention was the denominational home and platform for the late Reverend Dr. Martin Luther King Jr., who addressed every annual session until his death in 1968. In his valedictory address that year, President Gardner C. Taylor said:

As we remember Dr. Martin King's trials and triumphs, we remember our part in them. Progressive Baptists may take justifiable pride in the unassailable fact which must now forever be true, that when he had no spiritual [denominational] *home among Black Baptists, cast out from the house of his Fathers, Progressive Baptist gave him a Black Baptist* [denominational] *residence. You provided him with an address in the community of Black Baptists. Let angels record that truth and let succeeding generations bring their gratitude to your tent door.*

Progressive Baptists continue to struggle for full voter registration, education and participation; affirmative action against all forms of racism and bigotry; black economic empowerment and development; equal educational opportunity; freedom of religion by the restraint of all governmental authority and dictation in matters of faith, conscience and the church; the abolition of South African apartheid; and the realization of universal human rights and total human liberation. At all annual and adjourned sessions, there is scheduled a huge and impressive civil rights celebration to inform the constituents of the convention of current issues

and challenges, inspire them to continue and increase their participation in the struggle and garner fresh human and financial resources to advance the cause of full and total human rights.

Booth and his delegates were familiar with William Henry Jernagin. They encountered him during annual National Sunday School gatherings and heard him preach at National Baptist Conference (NBC) meetings. He served as president of the NBC National Sunday School and Baptist Training Union for more than thirty years. Both men and women were encouraged by him because his heart was dedicated to the youth of the church. He mentored, advised, chided, directed and connected youth with employment, schooling and housing. His death in 1958 created a vacuum within moderate voices that might have accelerated a split within the NBC. Yet the division between the black Baptists has been cast as the older, politically wired NBC unable to rein in the youthful, activist-minded younger generation. The difference of opinion over the involvement in the rising civil rights movement widened a cleavage between Joseph H. Jackson and Martin Luther King Jr. Jackson preferred a conservative path, while King joined with local activists using direct action methods. The PNBC provided the platform needed to nurture a national movement. These men and women forced America to live out its true Christian character of life, liberty and the pursuit of happiness for all citizens regardless of race, nationality or creed.

The ideals of the PNBC are resonant through Jernagin's fight for civil rights. Over the course of his life, he protested, sued, spoke out publicly, traveled internationally, published articles and testified before Congress on the injustice black people endured because their civil rights were denied through illegal and de jure methods. The 1950s found Jernagin in his eighties. He had returned from the South Pacific Theater, where he served as a military chaplain and ambassador for the National Fraternal Council of Negro Churches. He fielded commentary from black servicemen who experienced direct and micro-aggressions from white enlisted and military officials. In the post–World War II years, unlike those following World War I, servicemen and women returned to a country wrestling with civil rights legislation. Moreover, most colonial nations through Africa and the Caribbean were agitating for their independence; the global climate was ripe for people seeking equality and social justice. Jernagin knew this, and he contributed to the fight through his organizational influences. Therefore, his personal politics applauded the direct-action protests of young Baptists throughout the South. In a January 17, 1957 letter to Bishop W.J. Walls, Jernagin wrote:

Last week I was in Atlanta, Georgia, when they arrested five of our leading men and put them in jail. I went in jail with them until they were bonded and fingerprinted. I addressed the meeting at Wheat Street Baptist Church Wednesday night which Dr. Borders held and also the meeting that Dr. King had at the Ebenezer Baptist Church on Thursday afternoon before returning to Washington that night with a very fine spirit that our men are exhibiting in the South and the bus boycott. I felt it should encourage them all I could in their efforts. A thousand Christian leaders meeting in Jackson, Mississippi not only will encourage our brothers and sister in the South, but will attract the attention of the world the united effort of the colored ministry of America and let the enemies of our race know that we are determined we will not be satisfied until all of our citizens will become first class citizens and each of them will have a ballot to protect them.[3]

Clearly, Jernagin supported the protest measures employed by ministers and communities throughout the South. The ministerial careers of Booth and King reflect examples implemented by Jernagin. Booth was born in Mississippi in 1919. He pastored several churches, making his deepest roots in Cincinnati, Ohio, at Zion Baptist Church. He utilized his pulpit to galvanize his congregation and community to advocate for change. Conversely, King, a pedigreed son of prominent preachers, dedicated his youth to education and ministry. King became vice-president of the National Sunday School and Baptist Training Union in June 1958, a position he held for three years until he was removed by NBC leadership. William Jernagin lived a similar life. Like Booth, he was born in Mississippi, and like King, he dedicated his youth to education and ministry.

Jernagin served as president of the National Sunday School and Baptist Training Union over three decades, despite futile attempts to relinquish the position because he was popular with both young and old Baptist members. During his tenure, he engaged domestic and international issues surrounding race, discrimination, health, employment, police brutality and mentoring. He had the ability to see the larger issue at hand and reconcile the methods employed to fix or change an issue. Clearly, Jernagin appreciated the zealous energy of youth. However, he also fought racism from the pulpit, with his pen and during his travels. In a statement titled "On the Matter of Christianity and World Tensions," Jernagin wrote about the dangers of nuclear weapons and the need to secure civil rights for humanity. The threat of nuclear war troubled him because the technology did not seek to enhance life but possibly destroy it. In the nuclear age, injustice would target marginal

groups for additional exploitation, widening the circle of "outsiders" whose lives were in jeopardy.

> *I am constrained to believe that God in His wisdom, has been calling my people for some time to play a role today that they have played honorably throughout history; to speak and act in His name and to bring an end to this diabolic fencing with death on the part of other Governments, as well as our own, and as never before to call for PEACE.*
>
> *I truly believe that it is because of OUR VOICE, the voice of OUR CHURCH, which speaks for the most disadvantaged people in the country has not yet been raised above the horizon of our great battle for civil rights, that the powers of Government have been unmoved by all those who have spoken thus far. Perhaps there are those among the millions in colonial lands of Africa and the islands of the seas who are still waiting for us, the Negro Church to raise our voice, before they begin to move and do likewise.*
>
> *In the name of the millions of our people in the Southland, who are valiantly raising their banners for justice and freedom,*
>
> *In the name of those elderly folks among us, who have such bright and shining faces, convinced at last, that our time of victory has come,*
>
> *In the name of millions of our church brothers and sisters, long since dead, who have played so noble a part to keep this great living religious organization of over 10 million souls alive and flourishing,*
>
> *In the name of these thousands of beautifully dark children, who are the heirs of all we have built and fought for in His name;*
>
> *I speak out now, in the full knowledge that as church people we must prove once again, that in our hands, the hands of thousands of our ministers, lies the power to stop this awful march of nations to destruction. It is my belief that if we do this good deed, we will win.*[4]

Life was sacred, and the battle for civil rights needed to include a humane crusade to global temperance regarding the proliferation of nuclear weapons. Jernagin was clear on the power of unity and the gospel message of the Bible.

Unfortunately, his presence is fleeting in most literature about the explosive growth and impact of the National Baptist Conference on contemporary issues—the very issues he crusaded for during his ministerial career. How did that happen? There was very little documentary evidence of his impact that publicly survived his lifetime. Photographs, sermons, articles, essays, programs, degrees and other items were not deposited in

any archives, therefore making a scholarly analysis of his impactful life scantily available on reels of microfilm, footnotes to larger works and captions of existing photographs. Unlike the younger men he mentored, he did not leave a written memoir. He concerned himself with the education, direction and impact of the NBC National Sunday School on its youth and the larger society.

JERNAGIN IS RECOVERED

The archives of the Mount Carmel Baptist Church change this narrow focus. Housed in the walls of Mount Carmel is the most comprehensive collection of the personal papers of William Henry Jernagin. He served as the pastor at Mount Carmel for forty-six years. From that pulpit, he greeted various African heads of state; formulated the National Fraternal Council of Negro Churches, Washington Bureau; launched the Washington Baptist Seminary; hosted prominent Baptist, political and educational leadership; delivered informative sermons; mentored young men for ministry; and organized the earliest ecumenical civil rights prayer conference at the Lincoln Memorial. Meetings with Presidents Coolidge, Roosevelt, Truman and Eisenhower squarely placed civil and human rights issues on their radars. These events were nearly lost to history save the archives at Mount Carmel.

This work is an exploration of select events and organizations from the archives used to situate the life of William Henry Jernagin in Washington. Photographs, news clippings, letters, honorary degrees and essays document his life from Mashulaville, Mississippi, to Oklahoma City, Oklahoma, to Washington, D.C. Concurrently, there are numerous international travels across the Atlantic and Pacific Oceans to Africa, Asia and Europe on behalf of the NBC, United States government, the Washington *Bee* newspaper and Baptist World Alliance.

The Mount Carmel pulpit was enriched by the leadership of Jernagin. Washington proved to be a crucial hub of proto civil rights–inspired activity organized by Jernagin. Currently, there are active members of Mount Carmel who remember this prominent, clear-spoken, diminutive man of extraordinary presence. Some were baptized by him, others were married by him, one lived with him and others revered him. Subsequently, Mount Carmel pastors continued the Jernagin model of preaching a social gospel within a black nationalistic framework. The congregation is active. There

is an active Sunday school and Christian education programming. There is international outreach, as well as a library and archives program. Jernagin stated, "God intended for the church to shape society and not for society to shape the church." He intended to be that vessel used of God to shape a godly society.

Booth closed his article in *Nation's Prayer Call* by writing, "Just as it was inevitable that he [Jernagin] would become a World Christian leader, it was also inevitable that he would never lose the common touch. Dr. Jernagin is a spiritually youthful Christian who keeps on growing. Today his greatest interest is in youth in who he sees the hope of the nation. To the Baptist youth of this nation, he has ministered unceasingly and untiringly. He has led them into every door that is open and in addition has made many enduring friends for them."[5] Jernagin led the church in shaping society with love and truth while simultaneously mentoring young people. This work is a testament to his life and legacy, as expressed through the documents he created and people who knew him—the members of Mount Carmel and the residents of Washington, D.C.

ACKNOWLEDGEMENTS

E very book has a unique genesis. I met members of Mount Carmel in 2005 during a black history program. The late Yolanda Williams inquired about my work in archives and asked if I would conduct a workshop for them. Surely, I immediately agreed in part to stem the tide of potentially lost documents and history. The Library and Archives Committees of Mount Carmel proved me wrong. They already collected materials and operated a functioning reading room with archival materials for review. Their dedication preserved those items in anticipation of establishing a formal archival program. I thank those members of the Archives Committee: Deaconess Melton P. Baxter, Mrs. Sarah Lowery, Mrs. Virginia B. Moore, Ms. Deborah G. Robinson, Deaconess Cynthia J. Greenwood, Dr. Senior Ree Austin, the late Ms. Yolanda Williams, Deacon John T. Greenwood and Mrs. Margaret M. Long.

I have to thank God for leading me to projects and people whose enthusiasm and openness are welcoming and rewarding. This committee's dedication to seeing the development of archives through training and sacrifice is admirable. I pray abundant blessings on future archival projects, oral history programs, black history and church anniversary programs. Reverend Dr. Joseph N. Evans is affable and supportive. His personal library and insightful knowledge about National Baptist Church culture and leadership was helpful. Reverend Dr. Carey Pointer and his wife, Deaconess Barbara C. Pointer, shared their lived experiences about the private life of Dr. Jernagin. Dr. Pointer lived with Jernagin and absorbed

and observed a great deal about the manner of the man. I especially appreciate the interview. Additionally, I have to thank Reverend James D. Ross, general superintendent, Sunday Church School, Department of Christian Education, for allowing me to use space in the education office and for sharing stories on the importance of education to the National Baptist Church culture. Thanks, as well, to Deaconess Carmelita Y. Simmons, acting church secretary, for making copies and ensuring that I had a space to work. Thanks to Trustee Emanuel Bobo for providing ink cartridges for the archives copier and scanning some documents for me. Thanks to Deacon Ronald Lucas for offering warm greetings and the church sextons, Mr. Clarence C. Hicks and Mr. Jerome Moore, for bring materials to the processing area, assisting in clearing the storage area of clutter and unlocking the doors for meetings. The entire family of Mount Carmel has been supportive of the archives. I hope they are pleased. I learned a great deal.

I have to thank The History Press and J. Banks Smither. His ability to see the value in unique histories is amazing. Also at The History Press, Hilary Parrish, a rigorous editor—thank you. I want to thank the Oklahoma Historical Society; its electronic resources are amazing. They are prolific and easy to navigate. Dr. Taffey Hall of the Southern Baptist History Library and Archives fielded a number of my questions concerning the National Sunday School and Baptist Training Union. Her archives, *National Baptist Voice*, is an NBC publication that documented activities relating to the National Sunday School and Baptist Training Union. Those publications bring the voice and direction of Jernagin to life. At the Library of Congress, Jane Caulton of the National Library Services for the Blind and Physically Handicapped, Publication and Media Services, informed me of the historic newspaper databases. This resource allowed for subject searches across numerous titles of large and obscure black newspapers, which was an invaluable tool in tracking the progression of African Americans' social thought on local, national and international issues. Dr. Kenvi Phillips of Moorland Spingarn Research Center provided assistance in photographic research as well as locating a copy of *Black Magnolias*. Thanks to David Haberstitch of the Archives Center at the Smithsonian's National Museum of American History. David curates the Scurlock Photographic Collection, a rich source of images documenting African American history and culture in Washington from the 1890s to the 1980s. Lisha Penn at the National Archives and Records Administration assisted me with military records pertaining to African American chaplains.

Finally, I have to thank you, the reader. This story is larger than local history; it is global in scope. The life of William Henry Jernagin offers comfort in knowing that persistent dedication to one's truth has its reward. In a letter to Benjamin Mays on February 17, 1951, Jernagin wrote: "Nothing suits the devil more than when a strong man decides that he is going to give up the fight. I am not going to give up. I am going to ask God for more faith and fight for the thing that is right regardless to whom may differ. I have stood alone in a number of things but I have seen them come to pass. It is when we are willing to stand alone when God comes to our rescue." It is that sense of resolve that I hope to convey through the life of Jernagin. We share a faith in the same God and wish everyone would consider his invitation to joy and peace and, above all, endurance in this mortal race called life.

Chapter I

BECOMING THE CHURCH MAN

William Henry Jernagin was born at a crucible in America. The plumes of smoke from Civil War cannons long gone from the air throughout his home state of Mississippi were kept alive in the stories of many veterans who returned to their plantations to find decimated fields, ravaged homes and economic collapse. They were financially ruined, with their former properties now released, but they were legally citizens. The era of Reconstruction sought to rebuild America into one nation, under God, with liberty and justice for all. However, these turbulent conditions fanned embers of bitterness, loss and displeasure within the hearts of southern whites who had lost their way of living, means of income and sense of normalcy.

These embers—stoked at times by deliberate actions—turned violent rage into small fires that blazed throughout towns and counties, resulting in black deaths. Yet the black citizens remained and asserted their right to live as American citizens. Concurrently, members of Jernagin's generation drew their first breaths in this new postwar America as heirs to a dual legacy of slavery and freedom. Their parents opened schools, recounted stories, prayed for a brighter day and worked hard to provide and secure a foothold for their families. Many men of Jernagin's era were inspired by the thrift, tenacity and manliness of their fathers, uncles and elder brothers. Members of Jernagin's generation took full advantage of their position in time. They pursued education, opened additional schools, formed organizations and recruited membership; they also created newspapers and published articles about joys, pains, rights and wrongs endured by the community. Most

importantly, they built and filled churches that fed mind, body and soul. The black church birthed leaders, funded and strategized plans on behalf of the community. Jernagin joined the Baptist Church and dedicated his professional life to its mission.

MISSISSIPPI OF JERNAGIN'S BIRTH

William Henry Jernagin was born on October 13, 1869, in Mashulaville, Mississippi, to Julia Ruth Walker and Allen Fletcher Jernagin. Julia was born enslaved circa 1828 in the Abbeville District of South Carolina. It is believed that Julia was a mixed-race person of American Indian and African ancestry. Regardless, her enslavement resulted in her being moved and sold, ending up in Noxubee County, Mississippi. His father, Allen, was born on September 14, 1813, in Georgia to an enslaved mother and a member of the white Jernagin family. The union of Julia and Allen produced Arah (184?), Allen Fletcher Jr. (1851), Andrew Jackson (1853), Fannie (1861) and William Henry (1869). Julia preceded Allen in death, and another nine children were born to Allen Sr. by another wife. Allen was a farmer and carpenter.

Mississippi joined the Union as the twentieth state in 1817. The state name comes from the name of the river. The earliest inhabitants were indigenous Choctaw, Natchez and Chickasaw people. Other early people were Spanish explorers who arrived in 1540. The French established the first permanent settlement in 1699. During the first half of the nineteenth century, Mississippi produced cotton on large plantations that depended on black labor. In 1861, the state seceded over the issue of slavery. The Civil War wrought great havoc economically and in terms of loss of life and overall destruction.

Concurrently, the Choctaw and Chickasaw were removed from Mississippi west to Indian Territory in the military-forced trek commonly known as the Trail of Tears. This was a tragic period in American history. The 1830s Indian Removal Act provided speculators, plantation owners and other moneyed people the opportunity to acquire native ancestral lands. The physical and environmental conditions resulted in the loss of life. The journey—primarily by foot—marched all Indians regardless of age or gender over one thousand miles. During the trek, the U.S. government did not provide enough provisions, resulting in thousands of deaths from

malnutrition and hypothermia.[6] This violation of human rights would later cloud the pristine American sky for Mississippi native Jernagin.

Emancipation gave blacks freedom of mobility, but most remained on their former plantations. Those who remained were eventually absorbed into the system of tenant farming, by which they were basically given rights to cultivate land in exchange for a share of the product. This relationship continued the economic interdependency of blacks and white in a strictly vertical form, with whites on top as landowners and blacks on the bottom as tenants. This method of farming was prevalent in the South. Mississippi was no exception. In Mississippi, the vertical relationship was reinforced by the state constitution of 1890, when Republicans were overthrown in favor of Democrats. Prior to the 1890 constitutional change, blacks were allowed to vote, yet every election was "marked with bloodshed" in attempts to evade the Fifteenth Amendment. The end result was disfranchisement of black citizens stemming from literacy and comprehension testing coupled with increasing violence.

EARLY LIFE AND EDUCATION

The early life of Jernagin was a harsh reality. Life was made difficult for formerly enslaved people, evicted Indians and deposed white plantation owners. Although his father's mixed-race heritage—born to an enslaved mother and enslaver father—afforded him a privileged status during enslavement, those measures were strained after the Civil War. For the Jernagins, the position of enslavement was not internalized as one of inferiority. His father's sense of self and thirst for learning deeply impressed Jernagin. Enslavement left many African American parents and children illiterate. The community worked hard to provide opportunities to learn. Although both Jernagin parents were unable to read, Jernagin attended school, opened two seminaries and obtained three honorary doctorates over the course of his life.

The family secured a small farm of forty acres where they grew fruit and vegetables. They harvested apples and peaches for Juke Jernagin, a former enslaver. The young William Jernagin was extremely proficient; he earned the reputation of being a stealthy apple picker. Between sowing and reaping seasons, he attended local public schools, including Meridian Academy and Alcorn College for preparatory work. The opportunity to

learn increased his sense of justice and fairness. His pursuit of a career in ministry resulted in taking theological courses at Jackson and Alcorn A&M Colleges. For African Americans during Reconstruction, education was the essential inheritance everyone sought to receive. "On abandoned property throughout the state, as early as 1862, [were] established churches and schoolhouses for individual and collective improvement. Imperfectly literate former slaves and the state's few literature or semiliterate free blacks served as these schools' first teachers, and—young, old, male and female—were their initial pulpits."[7] African Americans in Mississippi demanded schooling, connecting it with freedom, sovereignty citizenship and self-determination. "Accordingly, countless African Americans purposely sought schooling and literacy, viewing them as the foundation for self-improvement and one means for attaining social and economic parity in the state's evolving postbellum political economy."[8]

Other opportunities education offered were being able to read the Bible and teach the young to understand their legal rights. The basic desire to learn elevated African Americans from being a cursed people in perpetual servitude—according to white supremacists who perverted the biblical curse Noah issued on Ham's son Canaan—to sons and daughters of God and siblings of Jesus Christ. The life of Jesus Christ provides an example advocates used in their fight for equity and justice. Moreover, the Roman government of Jesus's time paralleled the struggles African Americans endured during Jernagin's life in Mississippi. Jernagin's generation would use scripture and legal grounds to bring about justice in society. All too often "[l]andless, vulnerable, illiterate, and victimized by unscrupulous politicians and landowners, most [blacks] had to create strategies to challenge their subjugated and precarious condition."[9] They also knew that their successes and failures were interlinked because of their shared history of enslavement. As the group moved, so did the individual. Churches, fraternal orders and extended kinship networks provided for the elderly, prepared the youth and harnessed the power of working-age people. The educational atmosphere of Reconstruction-era Mississippi infused Jernagin with a clear understanding of education's necessity, importance and utility for rising generations of African Americans. "It demonstrated the self-determinist attitudes and practices of black Mississippians in pursuit of social and economic advancement."[10]

MARRIAGE AND OPPORTUNITY

Toward this end, once Jernagin completed his educational training, he was ordained into the Baptist Church in 1892. His first pastorate was at New Prospect Baptist Church in Meridian, Mississippi. In 1894, he organized black farmers in the Farmers' Alliance and Industrial Union to challenge Jim Crow legislation. Initially, the alliance was solely for white farmers; however, a "colored" branch opened for blacks with a membership of over one million members across twelve states. This early effort to galvanize labor was the beginning for Jernagin and a testimony to his influence and persuasion. Unfortunately, the Colored Farmers' Alliance fizzled out after a tragic incident in Texas. The other strains of farmers' advocacy morphed into a larger labor movement that contributed to the populist twentieth-century movement.

The fledgling Baptist Church of Mississippi was growing in strength and popularity. In 1812, there were 17 Baptist churches in the state with 92 pastors and 4,865 members. By 1860, there were 596 churches with 305 pastors and 41,482 members. Unfortunately, racism and the Civil War impacted the growth of the Baptist faith in Mississippi. The white Baptist State Convention organized in 1822 fizzled out by 1828 when it refused to admit black churches. At the close of the Civil War, with wealth no longer available and bruised egos smarting after the war's outcome, the white Baptist Church was a shell, while the black Baptist Church continued to grow. Black Baptists opened schools and colleges and constructed churches throughout the state to benefit the newly freed. Those serving as pastors and teachers were paid in goods, as cash was limited. Jernagin participated in the school movement. In 1896, he founded Meridian Baptist Seminary, one of the earliest educational institutions for blacks east of the Mississippi. It provided secular and religious instruction on the secondary school level from 1896 until its closure in the twentieth century. Meridian Seminary worked to provide correct pedagogical instruction for future ministers as well as create an educational standard for the African American pastorate. This had a dual benefit. It corralled the number of uneducated preachers teaching misinformation, and it allowed for a standardization of Baptist ministers, empowering them to move between sacred and profane worlds.

The spread of the Baptist denomination coalesced in the formation of the National Baptist Convention, USA, Incorporated in 1895. The men and women who created the NBC did not anticipate that their organization would become and remain the largest black religious organization, with

numbers in the millions of African Americans. The year 1895 witnessed a number of changes within African American culture. Frederick Douglass died, Booker T. Washington delivered his famous Atlanta Compromise speech and the American National Baptist Convention united with the Baptist Foreign Mission Convention and the National Baptist Educational Convention to form the NBC. Unlike the Methodist denomination, which is hierarchical, initially Baptists allowed for small congregations to form their own associations. The creation of the NBC would galvanize the strength and numbers of various local churches into a national body.

There were earlier attempts after the Civil War to form a national body of Baptists. During the nineteenth century, American Protestant churches in the North advocated for abolition and education. They attempted to coordinate with white congregations over moral issues dissonant with Christian values; unfortunately, the specter of race reared its ugly head, leading to the separation of Methodists, Presbyterians, Episcopalians and ultimately Baptists. The reality of needs pushed aside egos and territorial matters in favor of assisting the race from a place of strength and unity. *The Encyclopedia of African American History: The Black Experience in the Americas* states, "The NBC supported a variety of enterprises typical of American denominations. It sent foreign missionaries to Africa, collected funds for educational institutions, established newspapers and journals, and cooperated with other denominations in carrying out missionary activities among black Americans." Its first order of business was the creation of the NBC publishing board in 1896. The earliest publications were hymnals, a monthly newspaper and National Sunday School lessons.

The leadership of the NBC was principally male and southern born. During the 1890s, over 80 percent of African Americans lived in the South. Southern leaders promoted a campaign of racial uplift, while select northern leaders believed "religious segregation [w]as God's plan to compel the race to develop its own institutions and thus strengthen its place in American life." Jernagin's gospel would be a syncretism of both ideals. He knew firsthand the sting of racism and its debilitating effects. He also knew the resilience of African Americans who did not allow eternal pressures to lessen their sense of internal and community self-definition.

Prior to leaving Mississippi, Jernagin had two life-changing experiences: he married and was elected into Baptist leadership. On October 15, 1888, he married Willie Ann Stennis of Mississippi. She was born in Lauderdale County, Mississippi, in November 1866. Her parents, Thomas and Rosie Stennis, ensured that she attended school. She was educated in Meridian at

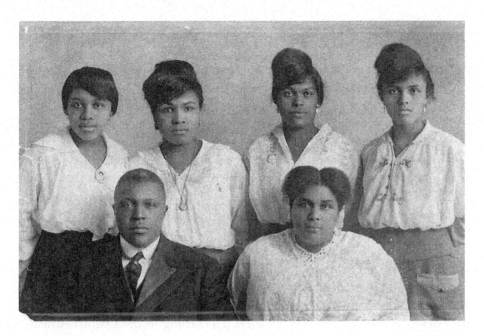

William Henry Jernagin; his wife, Willie Stennis Jernagin; and their four daughters, *left to right*, Lottie R., Rosabell, Mattie and Gertrude J., circa 1912. *Mount Carmel Baptist Church Archives (MCBCA)*.

private and public schools. Prior to being married, she worked as a teacher. Their union produced four daughters: Lottie R. (1889), Rosabell (1890), Mattie (1892) and Gertrude J. (1897). Willie Ann traveled with William to Oklahoma, New York, California and Washington, D.C. Their marriage endured the loss of two daughters. After a lingering illness of four years that claimed her mobility, Willie Ann passed away in 1943 after fifty-four years of marital bliss at the age of seventy-six.

When Jernagin was appointed to Tabernacle Baptist Church in Oklahoma City in 1905, he had pastored seven churches throughout Mississippi. He held a degree in theology. He had opened Meridian Seminary. He had organized farmers against injustice, served as superintendent of National Sunday School at Pine Grove Baptist Church, organized the Young People's Christian Educational Congress of Mississippi and was elected president of the Mississippi Baptist Young People's Union (one of the first organized under the new NBC structure). This incremental growth squarely placed the young Jernagin on the track to leadership within the NBC. His dedication to racial uplift, education, activism and youth would become hallmarks of his lifelong pastoral ministry.

EXODUSTERS, SEPARATISTS AND OKLAHOMA

A son of Mississippi, Jernagin was familiar with southern displeasure with African Americans prior to, during and after the Civil War. Many African Americans sought to move away from white areas to establish their own territory. Prior to Oklahoma, Kansas was a popular location where they sought to create a space for themselves.

Formerly enslaved people continued to farm in places and for people who had formerly enslaved them. Cotton plantations leased out their land and provided a sense of sovereignty for blacks. This short-lived vision of reality came crashing down when rents and supplies outstripped the money being earned. This new form of enslavement was debt peonage. The farmers were called tenants, and everyone in the family worked to acquire the money needed to survive. Rarely did a southern black person own his own farm, and if he did, threats and outright terrorism required vigilance. Kansas appeared to offer a solution associated with freedom. There African Americans could become homesteaders. According to the Oxford African American Studies Center, the 1862 Homestead Act "opened up the public lands of the west and [Midwest] to settlers, who were granted ownership of 160-acre tracts after they had lived on it for five years and 'improved' it (which meant building a dwelling on it of certain dimensions or cultivating crops upon it). Settlers were also permitted to simply purchase their land after six months of residence for $1.25 an acre." Concurrently, the infamous John Brown appealed to blacks. In 1855, he moved to Kansas. The passage of the Kansas-Nebraska Act of 1854 wrangled over whether the territory would be a free or slaveholding state. Regardless of the decision, which seemingly favored enslavement, Brown viewed violent means to end slavery a righteous option. In 1856, he became involved in the conflict, resulting in the deaths of five proslavery settlers. "In 1855 the Kansas Territory census showed 151 free blacks and 192 slaves living in the territory. Freed from slavery many began to come to Kansas during the 1860s and 1870s. In 1870 there were 17,108 blacks in the state."[11]

Scholars credit much of the increased population to Benjamin "Pap" Singleton. He encouraged blacks to consider moving to Kansas to improve their lives. He led a three-hundred-person group in 1873 to Cherokee County. The settlement flourished. He sought to organize another colony from Kentucky. Singleton's progress was evident. Unfortunately, his efforts ended when the railroad bypassed a black settlement in Nicodemus. There were a variety of settlements throughout Graham County, where Nicodemus

was; however, the agricultural economy required access to the railroad. Nicodemus, dubbed the "Largest Colored Colony in America," could not weather the storm of a national depression in 1890 coupled with racially motivated railroad companies that bypassed their town in favor of other areas in the state. The town of Bogue was selected, and people slowly migrated to better economic opportunities. Regardless, Nicodemus remained a small, prosperous black community until 1917. The 1930s depression hobbled the town, although the community remained dedicated to its sense of identity.

The racial climate that sparked earlier migration and the Exodusters— those who migrated to Kansas—loomed large around those African Americans seeking a space to thrive as American citizens. W.L. Eagleson devised a plan to acquire land in Oklahoma to create a bloc of black power and ultimately a black state. In an 1889 address, Eagleson stated:

> *There never was a more favorable time than now for you to secure good homes in a land where you will be free and your rights respected. Oklahoma is now open for settlement. Come and help make it one of the best states in the union… Give yourselves and children new chances in a new land, where you will not be molested and where you will be able to think and vote as you please. By settling there you will help open up new avenues of industry, your boys and girls will learn trades and thus be able to do business as other people. Five hundred of the best colored citizens of Topeka have gone there.*[12]

To accomplish his goal, Eagleson created the Oklahoma Immigration Organization, headquartered in Topeka with a satellite in Oklahoma. He appealed to educated, industrious, skilled African Americans to ensure that this new community would thrive without fear of penalty from railroads, white businessmen or fickle agricultural flux. Encouraged by a new opportunity, blacks flocked to Oklahoma. Eagleson's advertisement campaign propelled the political aspirations of Edwin P. McCabe. McCabe was a black separatist who tried to persuade the United States government to grant African Americans land in Oklahoma. "However, failing to achieve their original objective, the Territorial blacks proceeded to found all-black towns, which constituted bastions of Black nationalism, for McCabe constantly exhorted blacks to come into [Oklahoma] in such overwhelming numbers so that whites would be compelled eventually to turn over the entire region to blacks."[13] This idea for Eagleson and McCabe facilitated an avenue for economic advancement, self-help and racial solidarity, much of which continued to be elements of "frontier" living for African Americans.

Historian and native Oklahoman Arthur L. Tolson documented that Lincoln City (founded in 1889) and Langston City (founded in 1890) thrived until the 1950s. The populations dwindled as the towns remained predominately rural. "Although these towns came into existence as a consequence of white racism, they were doomed to failure primarily because black [separatism/nationalism] provided no permanent solution of the black question within the framework of American capitalism. Rather, the black Oklahoma towns served merely as temporary expedients for reliving racial tensions during the Oklahoma territorial era."[14]

The fractured reality of race, class and building political pressure was the Oklahoma that Jernagin encountered. His arrival coincided with the quest for Oklahoma to enter the United States. The territory promised to the Native Americans no longer existed, and the fears of whites that increasing numbers of blacks would provide them leverage required a national solution. The state of Oklahoma was composed of land acquired in 1803 with the Louisiana Purchase. The word "Oklahoma" is from the Choctaw meaning "red people." The relocation of Native Americans required the government to locate land on which to "put" them. By 1900, over thirty tribes were relocated to a space dubbed Indian Territory. Concurrently, Texas ranchers began to move into the area in search of new pasture land. Eventually, the United States government opened the area to settlement, creating a land run in which settlers were allowed to cross the border at a specific time to claim homesteads. Oklahoma became a center for oil production, fueling the state's early growth. On May 2, 1890, the Indian Territory was divided into Indian and Oklahoma territories. On April 22, 1899, fifty thousand people swarmed into the state for land claims.

The struggle for Oklahoma moved from land grabbing to legal wrangling between whites and blacks. Blacks did not want Oklahoma to become another southern state adhering to Jim Crow laws. They were fully aware that their number and relative financial prosperity displeased whites. They were referred to as "black locusts," an ill omen. Moreover, black farmers were making good on producing bountiful amounts of cotton, returning dollars to the community. The racial contentions boiled over into a national discussion covered by the *New York Times* on February 28, 1890, in an article titled "To Make a Negro State." The article revealed the political intentions of Edwin P. McCabe to become governor of the territory with President Benjamin Harrison's assistance. The *Times* asserted that if this happened, "[Harrison] would be assassinated within a week after he enters the Territory. There is rapidly growing anti-negro sentiment caused by the

aggressiveness of the blacks wherever they are strong. This feeling bids fair to unite the whites irrespective of party." These ugly feelings were spurred on by the formation of the First Grand Independent Brotherhood (FGIB), created by black men to attract settlers. "Slowly this new society gained strength until every negro voter wore a badge on which the letters 'F.G.I.B.' [appeared]. The power of the society was soon felt in a most unpleasant manner by the whites, who had fostered the little colony of blacks, helping them when crops failed and aiding them in securing credit." In the end, the *Times* concluded that whites outnumbered blacks yet the show of unity could depopulate the southern labor force.

JERNAGIN THE COMING MAN

Jernagin arrived in Oklahoma City in 1905. On March 9, the *Oklahoma Safeguard* reported, "Rev. W.H. Jernagin was invited by both of the Baptist Churches in Oklahoma City to fill their pulpits while he was in their city. A strong effort is being put forth to move him to the West and we think the thing is going to happen. Rev. Jernagin preached a forcible sermon at First Baptist Church of this city last Sunday morning to a crowded house. Subject, 'The Choice that Moses made.'" The *Oklahoma Safeguard* was a weekly newspaper from Guthrie, Oklahoma Territory, that included local, territorial and national news, along with advertising. It was published every Thursday. Its banner read, "In the Interest of the People." The paper was published by Buchanan Publishing Company, owned by C.A. Buchanan. In an issue from 1905, the paper ran the following note: "The Baptists of Oklahoma are getting together. That is right. 'In union there is strength. United we stand and divided we fall.'"

Ideally, Jernagin's desire was to grow the NBC and preach the faith of Christianity. The *Oklahoma Safeguard* reported on his installation service on July 6, 1905:

> *The installation of Reverend W.H. Jernagin as pastor of the Tabernacle Baptist church, of Oklahoma City was pulled off last Sunday in good shape. Rev. Jernagin, seated away back in that fine church, confronted with an audience of from five hundred to eight hundred, surrounded by all the big preachers, lawyers, doctors, teachers and big men of that great city, looked as though he was old Pope Leo. The choir, under the direction of*

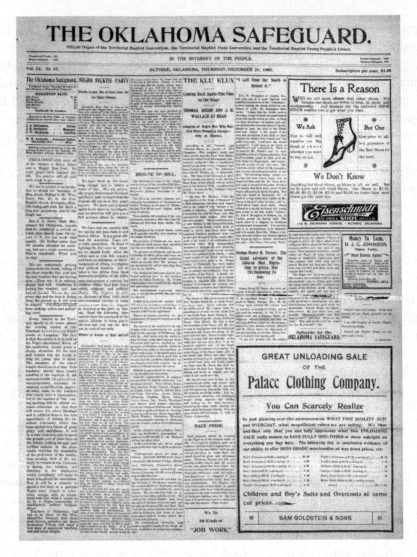

The front page of the *Oklahoma Safeguard*, December 21, 1905. This is the first issue listing Jernagin as associate editor. *Courtesy Oklahoma Historical Society.*

lawyer Harrison made some as fine music as we ever heard. Jernagin has a fine $10,000 brick church and also a fine set of people and they have a fine preacher.

Tabernacle Baptist Church witnessed growth under the pastorate of Jernagin. The church structure was completed and paid off during his nine-year

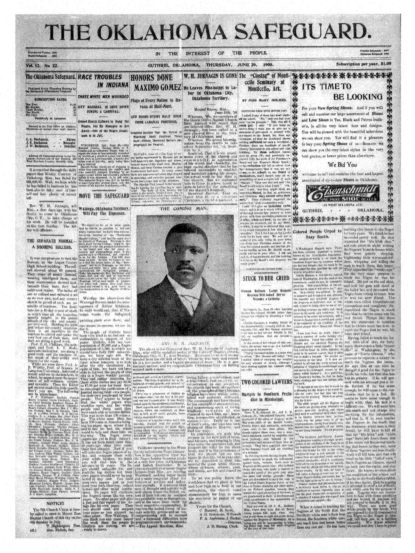

The front page of the *Oklahoma Safeguard*, June 29, 1905, featuring Jernagin, "The Coming Man," in his inaugural picture in Oklahoma. *Courtesy Oklahoma Historical Society.*

pastorate. Arthur B. Caldwell, in writing about prominent Negro Americans, says of Jernagin's Oklahoma years, "The church grew in strength and numbers and the pastor grew in popularity and in the esteem of his people."

However, the recalcitrant racism of the Progressive era forced Jernagin to advocate for social justice in Christian love. Through this blend of a social gospel, he engaged issues that moved beyond the congregation of his local

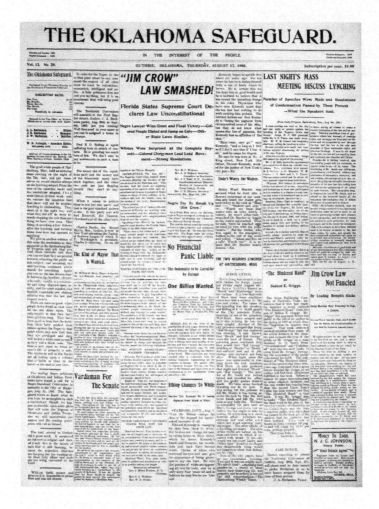

The front page of the *Oklahoma Safeguard*, August 17, 1905. The headline "'Jim Crow' Law Smashed!" is indicative of African diaspora and global concerns for Jernagin's ministerial career. *Courtesy Oklahoma Historical Society.*

church. This concern was evident in the articles published in the *Safeguard* in 1905. H.B. Decoster penned a piece titled "Race Pride":

> *It is so nice to have race pride; the kind that brings us in sympathy with every movement for the betterment of the race. Our advancement as a race depends largely on our race pride. We should rejoice and feel proud of those who have made a success. Those who are high in accomplishments*

give credit to the race. We should always speak words of encouragement for every good object. If we cannot give much money, give what we can and cheering words to others, thus be helpful and not obstructionists. Young men, cultivate the habit of industry. Work always, never be idle if possible; don't always be looking for a soft job; go down to hard work if necessary. It is a shame for able-bodied men to be doing little boys' work. If you are a man be like a man; show your manhood. Yes, our Creator has decreed that life should be one of activity; but the way some people live, it appears that they do not recognize this fact. Their civilization will never be a complete success as long as they will sit on boxes and barrels all day, rather doing some kind of work, is a dangerous thing; it often leads to wickness [sic] and crime.

For Jernagin, the needs of the church and the race were inseparable. His lawsuits, news articles, sermons, educational instruction/institutions, mentoring and modeling would contribute to the success of the NBC in a nationwide civil rights movement. The NBC facilitated civil rights movement tactics that Jernagin used in Oklahoma through the Constitutional League and the *Oklahoma Gazette*. The larger dreams of McCabe and Eagleson were dashed upon the rocks of a racial/political stalemate. Toward this end, Jernagin and others formed the State Constitutional League of Oklahoma. The league sought to secure the manhood rights of the race in concert with rights anticipated by other Americans. The advocacy of the league utilized members of the NBC, its publication arm and a network of churches to promote a just decision. Jernagin testified against the admission of Oklahoma into the United States because of Jim Crow laws against African Americans and native people.

In an undated news clipping, the Constitutional League of Oklahoma is described as vigorously contesting "Jim Crow Laws" of Oklahoma under the legal direction of attorney William Harrison of Oklahoma City. He brought suit before the United States Supreme Court in tandem with the Atchison, Topeka & Santa Re Railway Company. There is one feature of the case that would impact the Interstate Passenger Law. Harrison knew success would put an end to all "Jim Crowism" so far as interstate passengers were concerned.

"They will not then be subject to the intra-state laws of the South. Hence, we hereby appeal to every liberty-loving woman, man and friend of the Negro race in this country to make a contribution to the expense of fighting this case. We think it is high time, if Negroes wants liberty they should be

willing to pay something towards it. A few race loving [people] *in the Oklahoma League, led by Jernagin have made great sacrifice to bring this case through lower courts to its present stage." This article was signed by you for justice S. W. Layton of Philadelphia president Woman's Convention and Nannie Helen Burroughs secretary Woman's Convention.*[15]

In anticipation of the precedent-setting decision, Jernagin and the Mount Carmel Civic Club hosted a public meeting for the purpose of discussing its impact. The Washington *Bee* published an article on December 26, 1914, recording the gathering:

After a selection by the choir of the church and prayers by Rev. Reed, Rev. Jernagin stated the object of the case and presented Harrison...The prevailing opinion of each speaker was that the "race" through the untiring efforts of Harrison and Jernagin had gained a splendid victory. [Those gathered] *adopted a resolution...Whereas the opinion of the* [Supreme Court declared] *unconstitutional the Oklahoma law relating to certain common carriers which gives the colored citizens of the United States a part of that for which they have been contending for equal accommodations by railroads...be it*

Resolved, that the colored citizens of Oklahoma and the [government] *will take courage by reason of this opinion and further contend for their full manhood rights.*

Resolved, second that the civic organization of Mt. Carmel, and all the citizens herein assembled, do all their power to aid the colored citizens of Oklahoma and the United States to obtain their entire relief, for which they have been contending.

Resolved, third, that the thanks of the colored citizens of the United States are tended to [Harrison and Jernagin] *for the excellent fight they made in behalf of the colored citizens of Oklahoma and the United States.*

Despite the legitimacy of their larger protest, on November 16, 1907, both Indian and Oklahoma Territories were combined, resulting in the formation of the state of Oklahoma, the forty-seventh state admitted to the United States. As a southern-sympathetic state, Oklahoma politicians sought to limit the political power of blacks through disenfranchisement. This measure resulted in a lawsuit brought before the United States Supreme Court in 1915 seeking to outlaw the grandfather clause, an illegal measure to circumvent the U.S. Constitution. The grandfather clause was enacted throughout

many southern states after the Civil War, allowing potential white voters to circumvent literacy tests, poll taxes and other tactics used to impede African Americans from voting. The Supreme Court had to decide if the State of Oklahoma had committed a "crime of having conspired unlawfully, willfully and fraudulently to deprive certain negro citizens, on account of their race and color, of a right to vote at a general election held in that State in 1910, they being entitled to vote under the state law and which right was secured to them by the Fifteenth Amendment."[16] In the case of *Guinn v. United States* (1915), the U.S. Supreme Court affirmed the convictions. Justice Edward White went on to strike down the grandfather clause. He saw the Oklahoma law for what it was: "a bald attempt to disfranchise blacks." Justice White wrote that the act "inherently brings" discrimination based on race "into existence since it is based purely on a period of time before the enactment of the Fifteenth Amendment and makes that period the controlling and dominant test of the right of suffrage." *Guinn v. United States* was hailed in black newspapers as an important step toward ensuring basic fairness in voting rights.[17]

Jernagin left Oklahoma for Washington, D.C., when he was selected to be pastor of Mount Carmel Baptist Church. His Oklahoma years provided him a clear path for the civil rights fight, the vote and the enforcement of the equal rights protection clause of the Fourteenth Amendment. These were essential for African Americans in exercising their full citizenship.

Chapter 2
CIVIL RIGHTS ACTIVIST AND WASHINGTON RESIDENT

Jernagin, an experienced civil rights activist, thrived in Washington. His work with farm workers in Mississippi and the push to provide equality in Oklahoma allowed him to employ persuasive argument, educate his congregation and utilize the black press as tools to dismantle the Jim Crow system that suffocated the rights of blacks throughout the South. When he arrived in Washington, his fight against Jim Crow continued and would join a concerted effort of others seeking an end to segregation. Washington was a unique place for black people. There were prominent Baptist churches such as Nineteenth Street, Vermont Avenue and Metropolitan. Concurrently, there were distinguished places of learning, such as Howard University, a school created to develop social- and civic-minded citizens in a variety of disciplines, as well as Washington's public school system that produced great minds who found admission to Ivy Leagues and other notable colleges and universities throughout the country. Publicly, a viable black newspaper industry operated throughout the region with the Baltimore and Washington *Afro-American* and Washington *Bee.* Moreover, residents had access to national and international government officials. These ingredients coalesced into an ideal condition for Jernagin to employ his full-press strategy including protests, lawsuits and news articles to expose injustice, often in concert with other like-minded people. His full-press strategy held the federal government accountable to all citizens and would span four presidential administrations. A registered Republican, Jernagin dedicated himself to seeking improvement within the party as well as enforcement of local, state and federal laws. He

used the black press, his pulpit and sermons to force a change within the country of his birth on behalf of those rising generations he mentored and those previous generations he esteemed. He stated:

> *In this age, we must be aggressive or perish. We must be progressive, and we must seize every lawful opportunity to sustain ourselves as individuals and sustain ourselves as a Race. The leaders of our race should collaborate on the best possible means for obtaining the unity and harmony that will result in an outstanding success. Progress should be the password and by word of every Negro. It is his salvation in a chaotic and war-torn world.*[18]

MOVING IN WASHINGTON

The arrival of Jernagin in Washington in 1912 was greeted by national and local extremes. On the federal scene, the presidential campaign of 1912 reflected the simmering tensions between friends when huge stakes are up for grabs. Outgoing President Theodore Roosevelt changed his mind and decided to challenge William Howard Taft for the Republican nomination. Their quest for the Republican nomination lay in a struggle for the heart of the party. Many felt Taft betrayed the party, while others believed Roosevelt could unite the party. Regardless of their intentions, the fracture between potential candidates ushered in a new era of presidential politics. The former comrades hurled insults publicly throughout the summer of 1912. Clearly, Taft was favored by party leadership while Roosevelt had the voters who wanted another term of his social reform. Roosevelt led in popular polls during the primaries; however, Taft secured the needed delegate count. In disgust, Roosevelt left the Republicans to form the Bull Moose Party. His successful third-party campaign contributed to the shift in presidential politics. The four hats were in the ring: Republican Taft, Bull Party Roosevelt, Democrat Wilson and Socialist Debs. While the Republicans wrangled, the Democrats were being wooed by New Jersey governor Woodrow Wilson. The split benefited the Democrats. Wilson won with 42 percent of the popular vote, compared to 27 percent for Roosevelt, 23 percent for Taft and 6 percent for Debs.

Locally, Viscountess Chinda, wife of the Japanese ambassador, planted two cherry trees on the banks of the Potomac River. The nearly three thousand cherry trees were a token of goodwill from Japan to America.

This goodwill reflected the sentimentality of the age experienced by some. Conversely, for African Americans, 1912 was an eve of celebration for fifty years since the Emancipation Proclamation, yet the year closed with sixty-one known lynchings. The wooing of blacks by Wilson rang hollow after he was sworn in as president. During his campaign, he publicly stated, "Should I become president of the United States [blacks] may count upon me for absolute fair dealing for everything by which I could assist in advancing their interests of the race," but this worked in reverse. Richard Wormser, a documentary filmmaker, wrote, "He dismissed 15 out of 17 black supervisors who had been previously appointed to federal jobs and replaced them with whites. He also refused to appoint black ambassadors to Haiti and Santa Domingo, posts traditionally awarded to African Americans. Two of Wilson's cabinet ministers, Postmaster General Albert Burelson and Treasury Secretary William McAdoo, both Southerners, issued orders segregating their departments. Throughout the country, blacks were segregated or dismissed from federal positions."[19]

On November 16, 1912, the Washington *Bee* ran an article chronicling the installation service of Jernagin at Mount Carmel:

The Mount Carmel Baptist Church has been a scene of liveliness since November 7. [Jernagin] is a wide awake man. He is an eloquent and logical speaker, and his people think the world of him. His popularity is on the increase, and there has never been a man at this church who has ever been more honored and respected than [Jernagin]. The crowd Wednesday night was the largest that has been at this church during the revival exercises…The program was long, but interesting, and the addresses by those present were good. Seated in the pulpit were Nannie Burroughs, Rev. W.H. Brooks, Dr. Wm D. Jarvis [and other notables]…There is no man who is better appreciated and liked than he is. It is quite evident that he will win a host of friends and that his administration will be a success…There is every reason that he will succeed.

Mount Carmel Baptist Church is located in the Mount Vernon Square neighborhood, which originally was one of fifteen public reservations designed as focal points in the Federal City. In 1810, Congress provided funds to pave Seventh Street, NW, from Pennsylvania Avenue, NW, to Florida Avenue, NW (formerly Boundary Street), along Mount Vernon Square. This boosted activity along Seventh Street, attracting new residents and businesses to the neighborhood.

MT. CARMEL BAPTIST CHURCH
Looking North at 3rd and Eye Streets, N. W.
Organized in 1876

The Above edifice was purchase in 1913 under the pastorate of the Late Doctor William H. Jernagin from the Central Presbyterian Church in which the late President Woodrow Wilson worshipped (1913-1914), whose seat occupied also by President C. B. King of Liberia is being preserved by the present congregation in the main auditorium as a memorial.

A Fifty thousand dollar improvement completed in 1927 provided among other things the largest Community Center of color for the city, fostering Religious Education and Neighborhood Welfare interest. It is still the center of local denomination activity and Shrine of Prominent Race Churchmen visiting the Capital. Since February 18, 1958, the church has been in charge of the Reverend Percy Jernagin, nephew of our late pastor, the Late Doctor William H. Jernagin.

The Pastor-Elect is the Reverend R. L. Patterson of Winston-Salem, North Carolina.

We Welcome you to all our facilities and invite you to visit our prayer room on the Third floor and the W. H. Jernagin's Library in the Educational Building.

Mount Carmel Baptist Church original building. *MCBCA.*

In the 1840s, Mount Vernon residents petitioned the city council to create a public market. In 1845, the Northern Liberties Market opened and flourished. It provided both indoor and outdoor stalls. The market grew to 240 vendors by 1872. The growth attracted other businesses, a dairy bottling

plant, tailors and bars. "In 1893, Northern Liberties Market also became DC's first Convention Hall when a second floor was added to accommodate 5,000 spectators. In 1925, the owners converted the large second floor space into 50 bowling alleys."[20] There was a fire in the 1940s, and in 1985, the market was razed. One historic public building—the Carnegie Library, the former D.C. central library—remains a period structure in the neighborhood.

Mount Carmel Baptist Church was organized in 1876 by 275 former members of Second Baptist Church. The departing members, led by the Holy Spirit, formed new places of worship in various sites throughout Northwest Washington, including the Old Columbia Law Building on Fifth Street. During Jernagin's tenure, they resided at Fourth and L, NW. The congregation's growth required another move, which Jernagin orchestrated with the purchase of a church on Third and I Streets, NW. The church they purchased was formerly a Presbyterian church where former president Woodrow Wilson and his family attended.

On November 15, 1913, the Washington *Bee* ran an article chronicling the first anniversary of Jernagin's tenure. The women, men and youth are described as well dressed and brilliant in their programming to celebrate Jernagin. The anniversary spanned the week, with preaching, singing and salutations from a variety of ministers from the Washington area. Women shared their observations about the work and accomplishments of the pastor. A ministerial friend, E.A.P. Cheek, recounted that Jernagin's influence was growing roots in the city:

> *On arrival, I found the meeting in session, and a large, and enthusiastic congregation assembled awaiting my appearance, to deliver a Gospel message...More than twenty years ago, I met* [Jernagin at Jackson College]. *It has been our privilege to love and* [stay] *in touch with each other all these years...I have never seen a more devoted church and pastor.* [Mount Carmel] *is well organized, with a good deacon board, excellent choir, large and aggressive National Sunday School, with Mrs. Gibbons, widow of the former late pastor, as superintendent and a fine teaching force. I congratulate the pastor and officers, and their church for the order, liberality, and loving spirit among them...Through the kindness of* [Jernagin], *I was fortunate to visit all sections of Washington.*

Finally, a 1914 news clipping, "Mt. Carmel Church Big Crowds at Both Services," records the weeklong celebration of the move to the new sanctuary:

Entering Week and Jubilee—Rev. W.H. Jernagin's, D.D. Triumph Hundreds Turned Away—Many Distinguished Divines Participate. The Masons Lay the Corner Stone Monday Afternoon...The Mt. Carmel Baptist Church, has been an old landmark. The late Wm. H. Gibbons, the former pastor of the church was apparently a young man, and he was succeeded by [Jernagin] who pastored a large church in Oklahoma. For some time the officials looked around and hunted for several months for the proper man to succeed the late pastor, [Gibbons]. After many trial sermons had been preached by many different pastors, and after having heard [Jernagin], it was decided by unanimous vote of the church that he was just the man for the church. Existing conditions and the great work that had been done by this pastor during the limited time he has been pastor of [Mount Carmel Baptist Church], have fully demonstrated the choice the committee and the entire church made. There is no man better loved, esteemed and appreciated than [Jernagin]. He has not only been a success at the old corner from the very day he entered the Church, but has carried his congregation into a larger church and a better section of the city...the church formerly attended by Woodrow Wilson, and in one of the most aristocratic neighborhoods in the city of Washington. This edifice is indeed, one of the best churches in the city, with a seating capacity of at least 1,500.[21]

The article hails the innovation of Jernagin and his ability to grow the congregation through gifted leadership. The writer remarked that his improvements would increase the seating capacity. The new edifice received the congregation after a march from the old church at Third and L Streets, NW, to the new address at Third and I Streets, NW. The program noted Jernagin's eloquent sermon from Isaiah 45:2–3 titled "Attempt Great Things for God; Expect Great Things from God." The scripture reads, "I will go before thee, and make the crooked places straight: I will break in pieces the gates of brass, and cut in sunder the bars of iron. And I will give thee the treasures of darkness, and hidden riches of secret places, that thou mayest know that I, the Lord, which call thee by thy name, am the God of Israel." Following the sermon was a sacred music conference, including hymns such as "Awake Thou That Sleepest," "God of Our Fathers" and "Onward, Christian Soldiers."

Within his first four years of living in Washington, Jernagin would grow in stature within the NBC. Concurrently, his social network expanded to include Reverend Walter H. Brooks of Nineteenth Street Baptist, newspaper publisher William Calvin Chase of the Washington *Bee*, school founder/

Mount Carmel Baptist Church original building. *MCBCA.*

educator Nannie Helen Burroughs, activist William Monroe Trotter and clubwoman Mary Church Terrell. The Washington scene afforded him greater visibility and impact in part from the culture and intellect within the schools, clubs and nearness of the federal government. Areas of politics, education, diplomacy and media were a genesis for great ideas to percolate

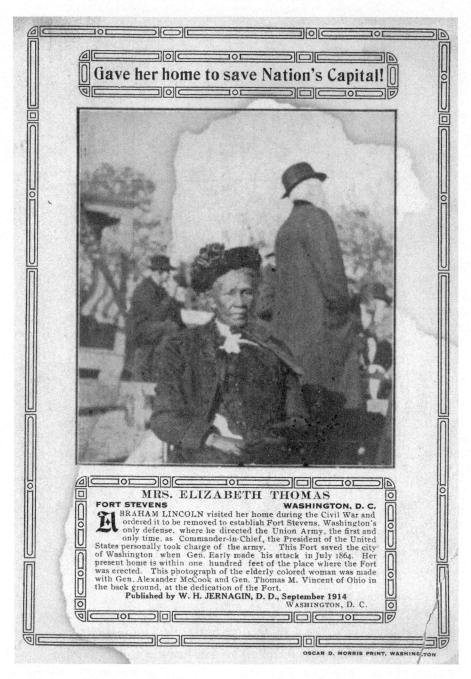

A Jernagin printed essay, 1914. *MCBCA.*

and diffuse throughout the country and the world. The five principal people—Walter H. Brooks, William Calvin Chase, William Monroe Trotter, Nannie Helen Burroughs and Mary Church Terrell—incorporated Jernagin into the organizations and issues that advocated for civil and human rights. Moreover, the interconnectedness of people afforded him greater opportunities to be impactful.

WALTER HENDERSON BROOKS AND NANNIE HELEN BURROUGHS

Walter Henderson Brooks was born enslaved in Richmond, Virginia, in 1851. His parents, Albert R. and Lucy Goode Brooks, reared their children in the Christian faith. Brooks received his early education in Richmond, at Wilberforce Institute in Ohio and at Lincoln University in Pennsylvania, completing his BA in 1872. His talent and thirst for education resulted in obtaining additional degrees, capped with a DD from Howard University. Influenced by the Presbyterians, possibly because of their educational evangelism throughout the post–Civil War era, Brooks joined a local congregation while at Lincoln. There were prominent Presbyterians who were successful in their respective fields, such as Archibald Grimke and his brother Francis Grimke, along with John F. Cook. Nevertheless, when he returned to Virginia, Brooks reconnected with the First African Baptist Church. While at Lincoln, he took courses in religion and theology that directed him into ministry, resulting in his being ordained in December 1876. As a young minister, he was assigned to the National Sunday School missions. Baptists were concerned with leadership and sought educated men to fill their pulpits and publish their instructional materials.

His first pastorate was Second African Baptist Church in Richmond, where he served for four years. He went to Louisiana to work for the National Sunday School missionary for the American Baptist Publication Society. In November 1882, he was appointed pastor of Nineteenth Street Baptist in Washington. Brooks revolutionized services at Nineteenth Street through the art of respectability melded with social justice and moral decorum. He built a National Sunday School library with books on various topics in religious and secular matters. Nineteenth Street affiliated with the NBC, bringing him into contact with Jernagin and others. Brooks's contacts within higher education and prominent membership in women's clubs the Helping Hand and Widow's

Mite of the church positioned him as a broker and statesman. The funds raised by the women's clubs provided latitude for Brooks to exercise influence against racism through financing endeavors to aid black citizens.

Concurrently, the educational system in Washington prepared black students for classical and industrial training. Parents and educators invested in providing quality instruction, apprenticeships and resources for their students. Moreover, the high schools were often staffed by college-level trained and able professionals whose instructions and expectations extracted great talent from their students. Many African American educators holding doctorate degrees could not find jobs or were not hired by white institutions; this resulted in their being hired by public school systems to teach high school students. At the same time, black women opened industrial schools to provide alternative forms of employment for women.

In the 1930s, Brooks and Jernagin advocated for Nannie Helen Burroughs and her National Training School. There was great discord because of an auditor's report that reported $10,000 under review. The auditor, M.M. Rodgers, alleged that Burroughs had been paid a $5,000 salary as principal of her school. In fact, she only received $200. The *Bee* noted that Brooks and Jernagin vigorously attacked the report and demanded a corrected report be issued. The NBC wanted Burroughs to deed the school and property to the NBC so as not to confuse her denominational office with the affairs of the school. Her school was a monument to Negro Baptists and was funded by contributors under Burroughs's supervision. Fearing another split similar to the publishing house, "every leading Baptist minister in the city of Washington [stood] by Burroughs." In a report to a women's convention at St. Louis, Burroughs stated:

> *The Training School is a woman's institution. It was conceived, developed, managed, owned and controlled by Negro Christian women. It is not only unique and successful, but hold*[s] *a place of respect and love in your hearts and in the hearts of thousands of others. We have something on Lincoln Heights* [a Washington neighborhood]—*something worth owning and glorifying. It is the life work of women by women for women. It is too sacred to be desecrated by confusion and too valuable to be thrown away by differences of opinion over policy...The* [NBC] *is distinctly and as it should be a "man's organization." Negro Baptist women should have a parallel national organization just as distinct and powerful...Members of the Women's Convention do not have any such rights in the* [NBC]. *Why should the* [NBC], *then control the Women's Convention.*[22]

Jernagin (front row, fourth from left), Nannie Helen Burroughs (to the right of Jernagin), Charles Wesley (front row, seventh from left), William Stuart Nelson (front row, ninth from left) of Howard University and others. *Library of Congress Prints and Photographs Division, permission from Scurlock Collection Archives Center, National Museum of American History, Smithsonian Institution.*

Burroughs's protracted fight with the NBC resulted in her keeping her school. By the close of the twentieth century, the property had become the home of the Progressive National Baptist Convention, another split suffered by the NBC over the civil rights movement.

Jernagin was clear on his views of women, their potential and issues, as evident in his thirty-plus-year friendship with Burroughs. He was sensitive to oppression and knew this in part from observation and conversations with his mother, wife, sisters and daughters. Black women were not afforded the safeguard of womanhood yet were subject to the scorn of racism. Education was the best weapon against oppression. Those being oppressed and those oppressing needed to learn about themselves and others. To Jernagin, a Christ-centered life would aid in this understanding. His daughters needed to arm themselves with faith and learning. Burroughs's school provided an education for two of the four Jernagin daughters. At one ministers' meeting, Burroughs introduced Jernagin as

> *one of God's noblemen—a wise counselor and a dependable, ubiquitous public servant. He is everywhere—one time or just coming in from another engagement. He specializes in the wholly impossible. He enjoys living in the midst of all of the important conflicts and challenges of his*

day, and in leading men on to tackle them without fear or compromise. He leads along the rugged way, where only brave self-sacrificing men travel. [23]

EDUCATING DAUGHTERS, LOSING DAUGHTERS

The Washington scene introduced Jernagin to the prominent and visible women in leadership positions. These women were race women committed to the cause of racial uplift, human rights and social justice. They experienced racism, sexism, classism and colorism, yet defeat was an option they refused to accept. Melding their strategies and pooling their resources, Jernagin's work with Burroughs and Terrell shifted the social order and dismantled Jim Crow in Washington case by case. He was familiar with Burroughs, in part from her work with the NBC and from her school. Jernagin placed two of his four daughters in Burroughs's school, knowing their futures were brightest under her tutelage.

Nannie Helen Burroughs was born on May 2, 1879, in Orange, Virginia. Her mother's example figured prominently in her life. When her father died unexpectedly, her mother, Jennie Poindexter Burroughs, moved the family to Washington, D.C., for a new life. Jennie sought out employment and education for Nannie. While attending school, Nannie was firmly entrenched in the Baptist Church tradition. She attended the M Street School, where she modeled and identified with teachers such as Mary Church Terrell regarding advancing the race in general and women in particular. Burroughs experienced disappointment at the hands of a high school instructor whose failure to apprentice her left her scrambling for employment. This disappointment opened a window of opportunity for Burroughs, whose membership in the prominent Nineteenth Street Baptist Church encouraged her sense of duty to race advancement.

She worked for the Baptist Church as a missionary while seeking to apprentice in domestic science/home economics. Unable to apprentice within domestic science, she poured her energy into church work and advancing the position of women. She published articles, lectured and encouraged women. She joined a number of women's clubs and remained an outspoken advocate of social justice as biblically mandated and civically needed. In 1909, she founded the National Training School for Women and Girls. The school motto—"work, support thyself, to thine own powers

appeal"—opted to create opportunities for others she herself was denied. The school offered domestic science and missionary training. The remainder of Burroughs's life was dedicated to racial uplift and the empowerment of women. In an article entitled "The Emergence of Negro Women," Kelly Miller described her:

> *As an orator Miss Burroughs is simply irresistible and sweeps all before her with the impetuosity of cyclonic power. Her effectiveness does not end in mere oratory. She is a tireless practical worker. By indefatigable energy, she has established in the city of Washington a school for training of Negro girls in household duties and domestic service. When we consider that domestic service is practically the only avenue open to colored girls on an unlimited scale, it will be readily agreed that there is no school in all the scope of Negro philanthropy that is more worthy of aid and encouragement.*

Burroughs's school offered a Christian ethos with practical training. Her efforts mirrored the work of Booker T. Washington and were found lowbrow to some Washington elite. Still, Jernagin understood the power of economy of bringing dollars into Burroughs's school, empowering his daughters and providing them with skills for their private and public lives.

The education of his daughters was followed by their marriages and continued membership in Mount Carmel. On January 6, 1917, the Washington *Bee* carried an article about the passing of Mrs. Mattie C. Sayles:

> *Mattie Clementine Jernagin Sayles, the wife of Harry Sayles (Letter Carrier) and daughter of Rev. and Mrs. W.H. Jernagin and sister of Lottie, Rosabel and Gertrude Jernagin died suddenly at her* [parents' house] *from heart failure, just as they were preparing Christmas dinner. Her death was a shock not only to the family but the entire city and friends; because she had every appearance of a healthy woman. She was helping in the preparation of the dinner when death claimed her…Mrs. Sayles was a graduate of Douglass High School in Oklahoma City and Myrtilla Miner Normal School, in Washington. In October 1914 she accepted a position with the National Benefit Association and Insurance Company. She was so proficient in her work that within six months she was promoted from Store-room to Chief of Claims which she held until her death.* [The company remarked that it] *will be extremely difficult for us to fill her place. I have absolutely no one in mind who could begin to approach her in the matter of Claim Adjusting.*

She was a great church worker and rendered valuable assistance to her father in his pastorate and was very devoted to her husband. The date of her death was their first marriage anniversary. But few young women have come to Washington and in such a short time weave their way into the hearts of many friends as did Mrs. Sayles. Everybody speaks of her character and the beautiful life she lived.

Death would claim another Jernagin daughter, Rosabel, in 1932 after a "gallant fight over a lingering illness resulting from a nervous breakdown." Rosabel desired a short funeral service with little fanfare, and her wishes were honored. Born in Mississippi and reared in Oklahoma, she attended Armstrong High School and Howard University, both in Washington. The loss of two daughters impelled Jernagin to rededicate himself to the youth of the race. He knew that the Baptist denomination needed dedicated members whose witness for Christ and social justice would usher in the truest democracy that Americans deserved to live in.

NATIONAL EQUAL RIGHTS LEAGUE AND NATIONAL RACE CONGRESS

William Monroe Trotter was born in 1872 in Boston, Massachusetts. His early life was filled with loving parents, an integrated neighborhood and a good education. He attended Harvard University and was inducted into Phi Beta Kappa honor society. His militancy stemmed from his father's intense displeasure with discrimination. James Trotter exposed his family to his select brand of radicalism that refused to ignore the sufferings of other blacks whose social status did not afford education and comfort. He refused half-pay from his Civil War service instead of the entire amount offered white volunteers. William Trotter believed that blacks needed to know the sacrifice of some established people and sought to impel others to join this consciousness. He partnered with George Forbes and established the *Guardian*, a weekly newspaper. The paper served as a counterpoint to the accommodationist position of Booker T. Washington. Forbes and Trotter directed their criticism at Washington because of his tolerance of tacit discrimination. They believed that established blacks needed to advocate for equal rights and respect. The *Guardian* successfully parried every Washington action with a stern critique. Trotter's vitriol for Washington

came to blows in 1903 at a lecture in Boston, resulting in Trotter's arrest and imprisonment. "DuBois has maintained that his call for the meeting grew directly out of the imprisonment of Trotter after Boston."[24]

In 1906, DuBois formed the Niagara Movement to unify efforts fighting against injustice. The Niagara Movement led to the formation of the National Association for the Advancement of Colored People (NAACP). Trotter and others formed their own organization, the National Equal Rights League (NERL), in 1908. "Its chief purpose was to arouse race opposition to [President Taft], although Trotter was careful to advise a fellow organizer to avoid the DuBois people."[25]

The NERL grew. In 1914, it had a publication and action program. In the same year, Trotter, along with others, openly rebuked Wilson for his double-talk. His campaign promise was, "If I am elected President, I will enforce the federal law in its letter and spirit, nay more, in the spirit of the Christian religion. I shall be a Christian gentleman in the White House." Wilson penned a letter to African Americans in which he declared his earnest wish to see justice done in every matter concerning them. He would enforce the laws of the Constitution throughout federal agencies, forcing wayward locales to comply. These words carried the hope of promise for African American citizens who lived in democratic hypocrisy legislated by amnesiac officeholders. In Trotter's letter, he stated:

> *No fair man would say that African Americans could find these words of promise consistent with a new executive policy of separate toilets, separate eating tables, separate working desks, separate wash rooms for them, and for them alone of all the many racial classes in this Republic. Nor would history's verdict be that square with segregation of this element.*
>
> *We told you in person before the election of our fear of southern sectional prejudice and asked you then, as a condition of advising [blacks] to support your candidacy, whether you, as [president], would protect us from its extension and you said you would. In what was tantamount to an agreement with these ten millions, you wrote "Colored fellow citizens"... Do not take from us now as President what you called us as candidate, "fellow citizens," for segregation forbids "fellowship."*
>
> *We confidently believe that the protest of African-Americans [country-wide, across industry, age and gender,] convinces you that Colored Americans did not interpret your words to mean segregation; they regard it as unjust, un-constitutional, un-Christian, and an undeserved limitation, a terrible injury and by virtue of its influence*

*for contempt, for maltreatment, for discrimination, for curtailment of
industrial freedom and civil rights, a calamity.*[26]

Dubbed lily-white, Wilson's administration contributed to the increased
radicalism of African American organizations and leadership. The spectrum
would span the gamut from conservative groups to liberal groups linking
themselves to socialist and communist ideologies. Trotter conversed with a
seemingly ambivalent Wilson. Trotter pushed for explanation of exclusion
and retrenched segregation, and Wilson responded with a belief that his
intensions were misconstrued. The two concluded peacefully without being
able to persuade each other to a particular side of the argument. Trotter
had the evidence of federal directives instructing that signage be placed
throughout government buildings in Washington designating separate
facilities and the abolition of positions held by black workers. The signs
came down; however, the verbal and cultural understanding was planted
that blacks were restricted and to be frustrated in attempts to access white-
only spaces throughout government buildings. Christine A. Lunardini noted
that segregation in federal agencies started with Theodore Roosevelt and
was maintained by Wilson. Southern by birth, Wilson believed himself a
progressive white who did not conflate segregation and discrimination. He
knew segregation existed; it was the normative style of the day throughout
the Deep South and spontaneously throughout the North. Irrespective of his
personal belief, African Americans were growing intolerant of indifference
from the federal government.

The well-intentioned NERL suffered because its visionary isolated
members contributed to internal discord. This obstacle manifested itself in
distrust, contributing to its short life. However, Jernagin served as president
after a consolidation with the National Race Congress (NRC), of which
Jernagin was president. In November 1927, the *Chicago Defender* ran an article
on the NERL and the NRC meeting in Washington to finalize a merger. At
the end of the four-day meeting, the leadership urged "[the] Race to eschew
and reject every proffered segregation, to fight in the courts every illegal
racial separation, to contend for the repeal of every legalized segregation,
to resist educational and residential segregations by protest, political reprisal
and economic boycott."

One of Jernagin's addresses published in the *Chicago Defender* on January
12, 1929, stated, "The nucleus [of the NERL]...still believed more in
emancipation than in the siren of contentment and in action for freedom
rather than in the opiate of superficial prosperity and the deception of

flattery." The article admitted that the organization suffered from internal strife; however, the needs of the community were larger, and everyone needed to increase economic cooperation and protect property and tax dollars used for public education.

In the *Chicago Defender* on June 1, 1929, the NERL petitioned President Hoover's law enforcement commission with a memorial pertaining to equal rights:

> *The memorial asserts that the violation of the 14th and 15th amendments and its permission by congress without enforcement legislation though such is mandatory under the Constitution, together with failure of reappointment of representatives in 1920 or since, did three things: gave the opponents of the 18th amendment a precedent for violating it, set up an example of lawlessness by those in authority, especially by congress, and permitted the disease to spread and become imbedded in the very nature of the people. The seizure of Haiti without declaration of war by congress is cited as presidential lawlessness as is federal segregation.*

This petition met with resistance and indifference but sought to bring before the president and the country an awareness of injustice. "According to [DuBois], during the campaign of 1928, when Hoover was seeking Southern votes, [Negro leaders] protested bitterly against the covert methods of Hoover's Southern friends in a 'campaign of racial hatred' in which 'the candidates continue to remain silent' on an issue…essential [to twelve million Negroes]."[27] Given select attention or omission bothered blacks; however, Hoover remained unresponsive to complaints. The Republican Party benefited from this open indifference for the next three presidential terms. Its streak came to an end in 1932 when black sharecroppers experienced a one-two punch from poor weather and economic hardships. This push-pull contributed to the Great Migration from rural to urban centers, where former sharecroppers encountered underemployment. The Depression robbed blacks of their jobs in favor of whites, resulting in higher joblessness and little federal relief. Hoover could not stem the tide of economic collapse, and African Americans needed hope and employment promised by Democratic candidate Franklin Roosevelt's New Deal.

In 1932, Hoover met with 150 black voters and declared that "the right of life, justice and opportunity are yours." His bid for reelection failed as the Depression spread and "last hired first fired" deeply impacted black people.

PLEADING THE CAUSE IN BLACK AND WHITE

Jernagin's first decade in Washington was fruitful. He grew in stature in the NBC, reaching higher platforms and audiences throughout the denomination. His reputation spanned the Southwest and increased in the middle Atlantic region. Advocating for Burroughs within the NBC positioned him as one seeking peace and equity for forward movement in Christendom and race progress. Schisms inspired by jealousy, gender bias and materialism were anathema to him, as evidenced in the showdown over the campus of Burroughs's school, as well as the NBC split over the publishing house. The NBC publishing house fracture, dubbed the "Chicago tragedy," impacted more than black Baptists; it affected the race at large in terms of efficiency, cooperation and forward movement. Burroughs issued a call to leading Baptists to come together and prepare a program for restoring peace and unity within the Baptist family. The Washington *Bee* ran an article on February 19, 1916—"Baptist in Peace: Memorial to the Baptists All Over the United States"—that called on notable ministers such as Elbert W. Moore, Philadelphia; J.C. Austin, Pittsburgh; A.C. Powell, New York; W.A. Taylor, Washington; E.T. Martin, Chicago; and several others, along with the Women's Department. The Peace Memorial was described as:

> *The Peace Memorial a strong appeal to reason—is being made ready for press. It is evident that the document will have great weight and will doubtless turn the tide sooner than the most optimistic even expect.*
>
> *The idea is to lay the basis for durable peace—not patched up peace and the instrument is to show such mental calmness and dignity as to inspire confidence in the unselfish purpose of those who lead the movement.*
>
> *Baptists certainly have greater reason for being together than for being apart and a document that will be presented to every organization by press and pulpit, and men back of it to inspire confidence is all that is needed. [Jernagin] was elected chairman of the Peace movement. He has contended from the beginning that the difference could be settled together, but never apart. He is, therefore, a good leader. He is backed by a host of the foremost men of the denomination, north and south.*
>
> *The peace sentiment will spread rapidly because the NBC is too great a body to be allowed to go to pieces over a struggle for control of machinery and positions.*

The memorial did more to reconcile members within the denomination than to establish a physical touchstone. Burroughs's call and Jernagin's leadership contributed to holding the NBC together. There would be future strife within the denomination, resulting in splits. However, they knew that unity was more impactful than loose bands of protest.

During these fledgling years, partnerships and friendships with Walter H. Brooks and other minsters—black and white—afforded Jernagin an opportunity to synergize his vision of civil and human rights for the Negro. He was not alone in his call to organization and unity. Meeting Trotter and working with the NERL galvanized his vision. Prior to involvement, he issued a call for a Colored Conference held at Mount Carmel in September 1916. Jernagin stated, "What the color[ed] man will be in this country depends not on what others may do for him, but what he does for himself, and it is time we were doing something." He went further to say that people must stop quarreling with "a stick which trips you up it will never help you on your journey. You must move the stick out of the way, and so it is with obstacles—you must move them out of the way and then let the race progress. You must not complain about the success of others, but make your own success. Color never yet made a race and never will. It is brains that count in this world." The conference was attended by representatives from fifteen states. It opened with a stated purpose of devising ways for the betterment for black Americans.

On July 29, 1916, Jernagin prepared a statement published in the *Baltimore Afro-American* titled "Jernagin on the Firing Line." This article vented his great displeasure with the governmental indifference in the end result of the Battle of Carrizal. The Battle of Carrizal was fought between the African American Tenth U.S. Cavalry and Mexican troops on June 21, 1916. Earlier in the winter of 1916, Pancho Villa led five hundred Mexican troops in a raid against the border town of Columbus, New Mexico. The town was defended by the Thirteenth U.S. Cavalry. Villa's men destroyed parts of the town and ransacked supplies before retreating. The casualties in this skirmish were roughly eighty Mexicans and eighteen Americans. The attack on Columbus resulted in a swift response from the United States government, which demanded justice. The justice required the capture or execution of Villa with the intention of discouraging future cross-border raids on American towns. Villa's men repelled pursuing American forces. Subsequently, the new governmental administration of Venustiano Carranza sought to limit the Americans' movements within Mexico, disregarding the justice sought in response to Villa's misdeeds. In June, General Pershing believed Villa was domiciled in Carrizal. He

selected two captains and one hundred soldiers from Companies C and K of the Tenth Cavalry to investigate. Villa was not located, and the Mexican army engaged the Americans, resulting in significant losses. When President Wilson learned of the engagement, he refused to retaliate, fearing action would provoke a full-scale war with Mexico. For many African Americans, the Battle of Carrizal marked an affront against their patriotism, diminishing their service and lives. Moreover, the Battle of Carrizal ended the search for Villa, as well as impeded border skirmishes. Jernagin's displeasure ended with a call to action by the leaders of the race to organize, advocate and demand change.

I have been prayerfully considering the situation which confronts us as a race in this country. When the news of the almost wiping out of the Tenth United States Cavalry was flashed over this country recently from Mexico it showed that our race has ever been ready and willing to shed the first blood when the dignity of the United States must be upheld. It must be admitted that it was quite a blunder on the present administration in its dealings with the Mexican question to allow a company of the best soldiers of the land to be shot down under such circumstances.

I believe now is the time for the conservative men of the Negro race out of every state to meet together in a conference, behind closed doors…[T]o present to the [Congress] that might arouse to consciousness that it would be willing to make the [Constitution] the instrument of protection that it declares itself to be in dealing with the civil and political rights of black men as well as white men.

It is pathetic and at the same time a travesty of American justice when our men offer themselves a willing sacrifice to avenge wrongs done white Americans in Mexico, when the country demands retribution…[Yet] tolerates and silently indorses [sic] the lynching of black men under its own flag nearly every week in the year. The president and the congress that are as silent as the sphynx on outrages committed on black men right in this country, speak in thunder tones and send a nation of men to avenge the wrong done white Americans in Mexico.

But we who are not at the front must not slumber in our tents, but rise up and demand the proper protection of black Americans in America, as well as protection of white Americans in Mexico. I hereby appeal to every race loving man and woman to express their views on the advisability of holding a conference in the city of Washington or some other convenient place. In a joint meeting of the Baltimore and Washington ministers' conference held

in June such a conference of leaders of the race was indorsed [sic]...*Let us catch time by the forelock, act wisely and stand firmly by our convictions. I will be glad to hear from* [anyone] *who approves the plan.* [Yours for the right of the Negro race].

Jernagin's passion for equity and justice did not seek to abrogate the Constitution but demand that its intent be experienced by all Americans, including Negroes. Jernagin, dubbed the "fighting parson," carried his tenacity into Washington, the black press and international issues. Involvement with the NERL and NRC radicalized his territory, allowing him to collaborate with like-minded civil rights advocates. His journalistic bent provided him a unique opportunity to travel to France to participate and document the Pan-African Congress, an early twentieth-century international organization, as well as keep his crusade public.

Chapter 3
CHAPLAIN FOR CHRIST AND THE RACE

World War I ushered in an era of conflicting growth for African Americans. Throughout history, they had demonstrated valor and courage. Black men and women served their country as troop supporters, secret agents and tactical assault forces from the Revolutionary War to the Spanish-American War. However, the World War I era was a modern Tantalus. African Americans were surrounded by war-won victory for freedom and democracy, yet they remained unable to expressly enjoy those same victories in America.

Jernagin understood war as a necessary evil. It offered black men another opportunity to demonstrate their patriotism, manhood and humanity. Historically, wars marked the end of one era and the start of a new one. The struggle to become a free agent and global citizen was directly related to the African American civil rights struggle. Howard University professor Kelly Miller wrote:

> From such a status of debasement, existing in an intolerable atmosphere of derogation and disrepute, the humble and humiliated American Negro sought the exaltation of international honor...He wanted to demonstrate both efficiency and initiative. He desired that popular belief conceive him as a man, not a monkey...He wished for the world to find in him [value]...He sought to neutralize the misteachings of Darwin and Defoe...These ideas the Negro wished to topple over.[28]

This idea of complete manhood fueled the push for civil rights and social respect. For black people, men in particular, the denial of those twin desires undermined them. Often their manhood was relegated to caricatures depicted in minstrel shows, bigoted literature and rampant stereotyping. Jernagin and his contemporaries fought hard to end the tacit acceptance and legal endorsement of vile images and overt injustice. The war spurred blacks on to organize internationally throughout the African diaspora where colonization, imperialism and injustice thwarted successful efforts to live as full citizens regardless of their country of origin. Jernagin joined this international effort and added an international aspect to his crusade for civil rights through a social gospel that fused the preaching of Christ with the promulgation of the race.

"STING FOR OUR ENEMIES, HONEY FOR OUR FRIENDS"

William Calvin Chase was an important publisher in Washington. His firebrand perspective on racial pride and politics spilled onto the pages of his newspaper, the Washington *Bee*. The paper was published weekly between 1882 and 1922, and Chase served as principal editor for more than thirty years. Many of the articles exposed segregation and discrimination locally. The paper also featured prominent race men and women who were crusading for equality through living their best lives to inspire the youth, blazing trails into new enterprises and confronting injustice on every occasion. Chase hired women; Nannie Burroughs served as his secretary. It is possible she connected Jernagin and Chase. The influence of Chase's mother is credited for his professional acceptance of women. She was a commanding and strong influence on him after the death of her husband when Chase was nine.

Chase was born free in 1854 in Washington. During his early life, he was exposed to integrated schools and neighbors. He became a lawyer who blended his legal practice with journalism for the majority of his life. He was politically active in Republican Party politics. He served as a delegate to the GOP national convention in 1912. "There was a dependent relationship between black journalist and politicians and political parties. This relationship may also account for Chase's emphasis on political equality rather than social equality."[29]

Chase and his paper were known for their in-depth, critical and direct articles on the people, policies and places where racial discrimination existed. His motto—"Sting for Our Enemies, Honey for Our Friends"—reflected his dedication to condemning racial violence and demanding a federal solution. The post–World War I rioting in 1919 was depicted by Chase as mob law. His political cartoons alluded to the complicit cooperation of Washington policemen. The police were known for decades as brutes who brutalized black residents. There were beaten, disfigured and dead black bodies serving as evidence in police misconduct. Mob law allowed for white rage to claim additional victims. The *Bee* used correspondents to cover national news; issues like lynching, racial prejudice in the federal government and abuse endured by servicemen found their space on its pages.

CHAPLAIN FOR CHRIST

World War I was the first man-made catastrophe of the twentieth century. Although it was slated to be a short war, the failure to implement a strategic battle plan and a deadlock between Allied forces (the United States, Britain and France) and Germany and the Ottoman Empire resulted in a protracted and bloody conflict. Nationalism spread the war from the European battlefields into civilian life. America entered the war after four years of observing with the determination of fighting a war to end all wars. The Christian Church reluctantly supported the war effort with the intent to inspire and sustain those fighting. The Federal Council of Churches (FCC), an interdenominational and interracial coalition of ministers representing over thirty denominations, drafted a statement of support during the crisis. Edgar Love, in "The Role of the Church in Maintaining the Morale of the Negro in World War I and II," expressed the function of the FCC during World War I:

> *This nation has entered the World War declaring itself bound to prosecute high aims. Yet it is the tendency of war to lower the spiritual resources of a nation. It lessens goodwill which is the heart of Christianity. It limits democracy, which the [FCC] had declared to be the expression of Christianity. It, therefore, creates a compelling duty for followers of Jesus to promote good-will and to increase the spirit and practice of democracy... The Christian Church must continuously create in the people the determination*

*that this War shall end in nothing less than a constructive peace that may
be the beginning of a world democracy.*[30]

The lofty goal of the FCC made room for black ministers to provide
succor for black troops. They created the personnel committee with
black and white ministers such as Howard University president Wilbur P.
Thirkeld, Tuskegee Institute president Dr. Robert R. Moton, Jernagin and
seven others. "As a result of [the] planning many colored churches located
near camps and in industrial communities sent [groups to invite workers] to
worship services and sociable recreation and entertainment for soldiers on
furlough or leave."[31]

While reaching out to soldiers, the planning committee forced the FCC to
examine itself. "We must confess that the Church and its ministry as related
to the welfare of the Negro has been too little inspired by the fundamental
principles and ideals of Jesus Christ. Communities that have expressed
horror over atrocities abroad, have been almost unmoved and silent when
men were beaten, hanged and also burned by the mob."[32] The planning
committee sought to have the FCC demonstrate the love of Christ in
speaking out against domestic injustice. "We call upon the pulpit, the press
and all good people to create a public sentiment that will support necessary
legislation for the enforcement of existing laws, that life, liberty and the
pursuit of happiness may be equally assured to all classes."[33] They believed
that the Christian Church should lead the charge toward true democracy
and the country would follow suit even in the midst of war.

Jernagin traveled to Europe as the NRC delegate to the Pan-African
Congress and used that trip to visit black troops in France. In "Race Must
Work Out Its Own Future Position," published in the *Kansas City Advocate*
on May 2, 1919, Jernagin reported on the poor treatment some black
servicemen received:

> *The Negro, especially of the labor battalions, had not received a square deal
> in France, and white officers had carried their race prejudice into France,
> and had not failed to exhibit it when the occasion presented itself. But I
> thank God I am able to say to you that in the face of all this our boys
> discharged their duty and are war heroes. Some of them died, and at the
> command marched into death like they were going into a banquet hall. The
> world will give them credit of being soldiers. We must do it ourselves, and
> not depend on others.*

CHAPLAIN FOR THE RACE

The armistice between the Allied forces and Germany happened on November 11, 1918. However, there were a number of faulty stops in attempting to end the war. The actual war ended with the signing of a peace treaty in Versailles, France, on June 28, 1919. The peace treaty, containing over 440 sections, was accepted by the German government without review or revision. Politicians of the time thought that the list deviated from Woodrow Wilson's Fourteen Points, while the British government thought the measure too austere. Wilson's Fourteen Points sought to direct America's international policy during and after the war. Victors and vanquished both faced an uncertain future fraught with the reality and challenges of financial losses.

The defeat of Germany signaled to African Americans the long-awaited beginning of the end to de jure segregation. They believed that their long-standing military service and recent participation demonstrated loyalty to America. Those who were educated and dedicated foot soldiers and patriotic citizens sought to destroy the lingering residue of plantation imagery that littered popular culture. In the climate of simmering racial tensions, lynching continued. Despite wanton violence against black men while in service uniforms, the vast majority of blacks remained dedicated to realizing the American dream. In *The Negro's Reaction to the World War*, Kerlin wrote:

> *The Negro's actual part in the War provided the basis for his holding his country to its lofty declarations and implied promises…Fully realizing and insisting that the Negro is a man and an unexcelled American and should enjoy and possess every right and privilege of other American workmen… Asking nothing for ourselves which we are unwilling for others to have in rightful proportion.*[34]

In *Kelly Miller's History of the World War for Human Rights*, he states:

> *What American will dare stand before any Negro trooper returned from France and thus mock and deride him? The Negro has proven his power of moral restraint while guided by leadership of his own color. As a social being he has sacrificed his life for the highest form of social existence, democracy. Who then, is there to call him alien? Today he is no longer Negro, nor Afro-American, nor colored American, nor American of African descent, but he is American—simply this and nothing more.*[35]

Unfortunately, the summer of 1919 extinguished most hope. The lingering embers of tensions between blacks and whites throughout the country were fanned into flames when the rapid demobilization and a floundering economy led to high unemployment and inflation. Moreover, the new esteem brimming from black servicemen antagonized whites who were not prepared to elevate them from second-class citizenship to equal citizens. A record seventy-six lynchings in six weeks included a dozen black veterans still in uniform.

The *Voice of the Negro* published a series of letters from around the country by members of the National Race Congress. The series, labeled "The Negro's Reaction to the World War," provided a kaleidoscopic perspective on the injustices blacks suffered in the wake of the war. They pleaded with the federal government to institute controls and punish perpetrators to stem the tide of violence. Jernagin's presidency and residency in Washington propelled him into the spotlight. The opening article remarked that the NRC's location in Washington was intentional because of access to federal officials:

> *If* [the federal government] *cannot make laws, it can make sentiment, which is more powerful than laws and which is ever the forerunner to all reforms…The colored people everywhere recognize the critical conditions that are confronting us and realize that only by prompt and vigorous action all along the line may we hope to enjoy the rights and privileges by the Constitution and the laws. The propaganda of those who would despoil us of our birthright of citizenship is spread constantly and universally— openly, where it is possible to be open—and with a subtlety that almost defies detection, where secrecy* [is] *necessary to accomplishment of their devilish purposes.*[36]

Moreover, many whites feared black radicalism and reacted hysterically to rumors of subversion and threats of violence. These events stirred them to action, and this time, white aggression met with black organized defensiveness. Washington endured a riot where numerous blacks were randomly assaulted by roving bands of discontented whites. *LaFollette's Magazine* reported that mobbing of helpless Negroes in the capital of this country is the nation's everlasting shame. It blamed lawless whites who feared equality with blacks. This was an ugly counterpoint to the federal government seeking to become custodians of world peace and instructors in democracy to less enlightened nations when on its own streets innocent, God-fearing, law-abiding black citizens were being murdered. In various cities such as East St. Louis, former

servicemen witnessed the depravity, lawlessness and insanity of white mob violence. They knew an accomodationist stance and "being good" was not going to placate American society or force the changes needed to live as first-class citizens. Concurrently, older black men realized that the entire African diaspora was convulsing in response to white fears. They decided an organized and unified strategy and group served the race better to bring about a desired change worldwide.

The collective response by African American men after 1919 was a call to organize. They realized that organizations and collective strength was the best method to bring attention, solution and resolution to injustice throughout society. Organizing through cooperatives with respect to religious, political and ideological differences, the NERL and the NRC collapsed into the NAACP. In 1919, the Pan-African Congress (PAC) was created, followed in 1935 by the National Negro Congress (NNC), among others. The NNC spawned a youth group, the Southern Negro Youth Congress (SNYC), while the PAC served as the seedbed for the decolonization of Africa. Jernagin affiliated with both groups in hopes of sharing ideas across generations, fueling his full-press strategy.

PAN-AFRICAN CONGRESS AND THE *BEE*

Minkah Makalani stated, "Pan-Africanism represents the complexities of black political and intellectual thought over two hundred years. One of the earliest manifestations of Pan-Africanism came in the names that African peoples gave to their religious institutions." The desire to worship freely the creation of the black sacred cosmos provided the needed shelter from a hostile world.

In *Organizing Black America*, the Pan-African Congress is chronicled from its birth as an idea crafted from two major elements: the collective African consciousness for political rights and the creation of the African Association, formed by Henry Sylvester-Williams in London in 1897. Sylvester-Williams desired to galvanize West Indian natives living in London through Africa, not individual Caribbean nations, through the belief that all were victims of colonialization and therefore brothers. In 1900, Sylvester-Williams orchestrated the first Pan-African meeting, summoning people from around the globe, principally West Indians, although Africans and Americans attended as well. W.E.B. DuBois was in attendance. That meeting appealed

to DuBois's intellect, and he served as the chief apostle of Pan-Africanism for the remainder of his life. People read papers discussing slavery, economic inequity and political and social conditions throughout the African Diaspora; seemingly, all accounts mirrored one another. The outcome of the first meeting was a document entitled "To the Nations of the World," addressing the heads of government and demanding reforms throughout colonialized Africa. There were three distinct outcomes from the first meeting: a call to protect the rights of African/black citizens in America and Europe, as well as respect the sovereignty of Haiti and Ethiopia. They also decided to create an organization based in London with branches throughout the world. Lofty and well-meaning intentions fell upon the imperialistic ears of Europe and segregationist aims of America.

World War I revived an idea in DuBois's mind. The governments of Europe and America met in Versailles to sign a treaty, and DuBois attended this gathering as a delegate of the NAACP. He believed that the service of black troops and the spirit of democracy would extend to an examination of the treatment black soldiers experienced under white officers. "Moreover, DuBois expressed hope that the peace treaty would address 'the future of Africa' and grant self-determination to colonized peoples."[37] Woodrow Wilson issued his Fourteen Points plan leading to the establishment of the League of Nations, which called for a recognition of sovereignty against colonial claims.

Motivated by the progress in Versailles, DuBois and Blaise Diagne, a member of French Parliament and Senegalese by birth, hosted the inaugural Pan-African Congress in 1919 with funding from American civil rights groups. "The Congress, attended by sixty representatives from sixteen nations, protectorates, and colonies, however, was more 'pan' than African since most of the delegates had little, if any, first-hand knowledge of the African continent."[38] Notables from America included college presidents, educators, club women and ministers. John Hope, president of Morehouse College; Addie Hunton of the YMCA; Rayford Logan, Howard University professor; Ida Gibbs Hunt, women's activist; Jernagin; and others participated in this legendary effort to internationally organize the race on behalf of Africa and America.

At the initial meeting, they drafted a code of law calling for international protection for African natives, supervision of colonial economies, access to quality education and methods for native people to enter political office. Over the course of Jernagin's life, there were six Pan-African Congress meetings, and each gathering pushed for respect and recognition of African

Jernagin with others. Jernagin is in the front row between men with light-colored suits at the Tomb of the Unknown Solider in Paris, France, 1934. *MCBCA.*

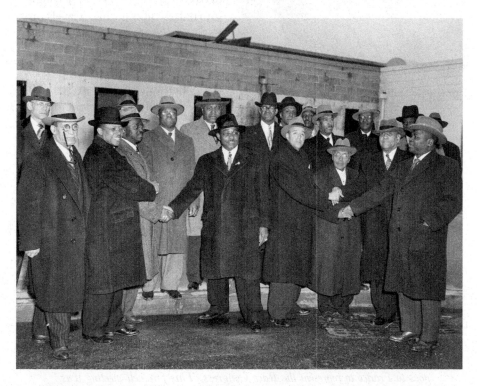

Jernagin with a delegation of men, unidentified/undated. Jernagin is in the front row, third from right. *MCBCA.*

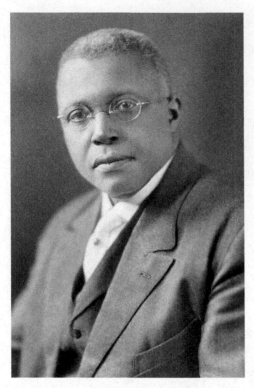

Jernagin portrait. *MCBCA.*

people and countries. Jernagin lived to see Ghana become an independent nation. He traveled to Ghana to celebrate the presidential inauguration of Kwame Nkrumah representing the NBC, National Fraternal Council of Negro Churches and Baptist World Alliance.

The first meeting was difficult for some to attend, as passports were denied. Jernagin had no such problem. As pastor of Mount Carmel, president of the NRC and correspondent for the *Bee*, he sailed to Paris on February 5 and arrived on February 26. Jernagin journaled about his travels to France, and those experiences ran in the *Bee* from November 1918 to April 1919. On November 9, 1918, the paper announced that Jernagin would travel and correspond with the *Bee*:

Elsewhere in the Bee *will be seen an appeal to the colored Americans for funds by the president of the Race Congress* [Jernagin]. *This appeal should be liberally responded to by all lovers of liberty. Let there be no laxity in our enthusiasm.* [Jernagin] *deserves credit for the noble fight he has made to blot out caste and race prejudice. There is a great deal of work before us. There is lots to be done before the colored American sees real light. Act today. Now is the time.*

Jernagin's departure was heralded with fanfare in New Jersey en route to the ship. On February 15, 1919, an article about the party recounted:

He is a man of great force of character and a prominent race man. He goes to France to represent the Race Congress. This farewell meeting was held at the Salem Baptist Church of which Reverend Dr. R.C. Judkins is

pastor. Ample preparations had been made and the meeting was one long to be remembered. The Baptist Ministers Conference of Newark and vicinity was largely represented...Stirring patriotic addresses were delivered... [Jernagin] set forth a program for race development that was assuring. The music by the choir was good...The short addresses around the table were full of spice and everything conspired to make the evening one of profit and pleasure. [Tomorrow he is off to New York and then Portland, Maine, from whence he sails for France.]

Once aboard the ship, Jernagin reflected on being a black man. That reflection ran on March 8, 1919:

My Dear Editor Chase: I am almost in sight of London. At the rate we are traveling we shall reach London by 5 or 6 o'clock. I am the only colored American on board this ship. I was a little lonesome until I was asked by a few of the white passengers where I was going, and when I informed them that I was bound for Paris to the Peace Conference. I had plenty of company. My trip was a pleasant one, as I met quite a number of representative people en route to the conference. I shall write you on my arrival in Paris.

Jernagin missed one day of the meeting; however, he did attend the business session. At that session, a nine-point resolution was run on March 29, 1919:

The Negroes of the world in [PAC] *assembled demand for the interests of justice and humanity and for strengthening the forces of civilization that immediate steps be taken to develop the 200,000,000 of Negroes and Negroids. To this end we propose:*

That the allied and associated powers establish a code of laws similar to the proposed international code of labor.

The League of Nations establish a permanent bureau, charged with the special duty of overseeing the application of these laws to the political, social and economic welfare of the natives.

The Negroes of the world demand that hereafter the natives of Africa and the peoples of Africa descent be governed according to the following principles: [land, capital, labor, education, medicine/hygiene, the state, culture/religion, civilized Negroes and the League of Nations].

The detailed explanations are similar to future civil rights demands in America. For example, education was a right to every native child. They should be taught both native and "trustee nation" languages with the intention to produce native teachers. In the state, they demanded that natives of Africa have the right to participate in the government as subjects, not objects. Jernagin was the third signer on the published resolution.

Another article on March 29 documented:

> [Jernagin's] *address to the conference was delivered by him and translated in French. It was received with great applause.* [Jernagin] *was the only member of the delegation to receive a passport. He went as the representative of* The Bee *as well as a delegate from the NRC. His reception by the distinguished members of the* [PAC] *and the French people was very gratifying to the Americans in France.* [Jernagin] *will arrive in America next week, and his conference and the members of his church and the citizens of Washington will tender him a royal reception.*

In 1921, Jernagin attended the second PAC; however, this time his travels aroused suspicion from J. Edgar Hoover. In a series of letters pertaining to the 1921 PAC, the British Embassy noted, "We know nothing very definite about [Jernagin] except that he is reported to be very radical in his views and, as the regulations regarding admitting foreign born colored people to Sierra Leone are very strict, I wondered if you could supply us with any information regarding this gentleman." The response from the U.S. Department of State indicated that Jernagin's traveling to Liberia was a visit to Della Harris, a Mount Carmel missionary who was ill, and he would be joined by several other pastors who intended to visit several ports in West Africa. There is no further discussion on Jernagin traveling to Liberia in 1921, although he did travel to Liberia several times during his life for ministry purposes.

By 1930, he was eighteen years into his pastorate. His congregation grew in number from the low hundreds to nearly one thousand members. He purchased new property and operated as a satellite office for the NERL and NRC. In April 1926, a literary and musical program at Mount Carmel accompanied the unveiling of the bust of Jernagin, at which the sculptor, Normil Charles of Haiti, was present. The presentation of Charles by Napoleon J. Francis, deputy general of Haiti, demonstrated the international renown Jernagin established during his first two decades in Washington.

In 1920, Jernagin and the NRC cordially received President-elect C.D.B. King of the Republic of Liberia, who visited Washington on a special

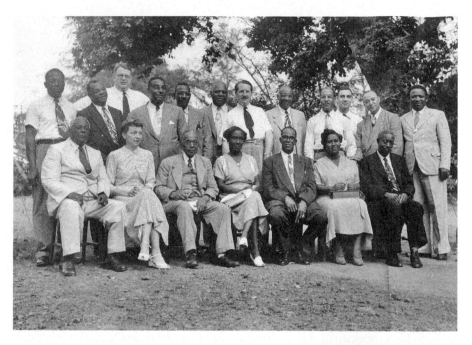

Jernagin (seated, third from left) with a delegation in Ghana, circa 1957. *MCBCA.*

Jernagin (seated, white suit in center) with a large delegation in Liberia. *MCBCA.*

government mission and for observation and recuperation following the Paris Peace Conference. Jernagin welcomed President King to America on behalf of all black Americans. The NRC pledged support to the Liberians in the spirit of uplift and development of its "Sister Republic" in Africa. It viewed Liberia as the open door through which the New World might enter the inner life of Africa. Jernagin noted that black Americans were proud of Liberia's progress as a recognized government and loved it next to America because of its oneness with "us in blood, religion and language."

In response to the race riot in 1919, the NRC advocated for the abolition of "Jim-Crowism" and a push for the ballot in seeking proper treatment for the race. The ballot would allow for the selection of the right leadership. They wanted "real men, fearless men, men who would contend for the rights of the race on all occasions and not sell out." Moreover, the riots were a product of a lawless element of society. The solution lay in the cooperation of the law-abiding citizens, both black and white.

In 1921, the increasing demands of ministry and organizational offices put a physical strain on Jernagin. His short frame coupled with aging restricted his movement. He tipped the scale at 210 pounds, making simple activities a bit burdensome. To solve this problem, he decided to adopt the diet espoused by St. Louis Albert Estes. Estes was a trained doctor and proponent of raw food diets. He believed this method of eating could cure most chronic illnesses. Jernagin's diet included a large proportion of freshly juiced fruits and vegetables and little amounts of meat. His liquids were principally lots of milk and mint/alfalfa tea. Along with healthy eating, his exercise regimen included cycling, swimming and jumping rope. His frame melted to 150 pounds, and his healthy living inspired numerous articles and marvel into the 1940s.

Jernagin welcomed the prospect of a new decade and president. In an essay titled "A Survey of the Republican Party and the Negro: How to Vote and Why" on October 9, 1932, Jernagin responds to a puzzled young voter. The first-time voter was a "colored American in a northern state" educated in public schools. The essay, released by the Republican National Committee, tacitly sought to keep blacks loyal to the party. The Republicans of Abraham Lincoln were fading away and siding with southern whites in racial camps that excluded blacks with horrendous consequences, from unemployment to racial violence to callous indifference. The opportunity of platform over party was a gamble, and Franklin Roosevelt benefited. The Democrats captured the White House and would be allies in the quest for civil rights.

Chapter 4
CRUSADER FOR JUSTICE, PEACE AND BROTHERHOOD

The 1920s, 1930s and 1940s afforded Jernagin new opportunities to connect with like-minded people and promote his Christian ideal internationally. The PAC introduced him to a variety of international contacts. He met President Charles Dunbar Burgess King of Liberia. King was a politician in Liberia of Americo-Liberian and Freetown descent. He was a member of the True Whig Party, which ruled the country from 1878 until 1980. He served as the seventh president of Liberia from 1920 until 1930. Jernagin welcomed President King to Washington after the PAC and provided him an informal tour of the city. This relationship with Africa included several trips to western countries. Jernagin attended the inaugural activities of Kwame Nkrumah and fostered understanding between Africans and Americans.

In 1926, Jernagin was elected president of the National Sunday School and Baptist Young People's Union Congress of America. He would innovate this position and seek to meld social consciousness and Christian responsibility. At the age of fifty-seven, he was seasoned, established and capable of directing the curriculum young Baptists needed to know pertaining to scripture and society. Concurrently, he served as president of the General Baptist Convention of the District of Columbia. Those two positions, along with his own ideology, compelled him to found the Washington Baptist Seminary.

The seminary would teach the history and doctrines of the Baptist Church. Second Baptist and Mount Carmel hosted the fledging seminary for thirteen years before they purchased property at 1600 Thirteenth Street,

NW. Ministers trained at the seminary served locally, while others served in domestic missions work. Jernagin's impact resonated through the seminary for seventy-seven years, in part from being served by two presidents during that time: Reverend Dr. J.L.S. Holloman (1926–70) and Reverend Dr. Andrew Fowler (1970–2003).

The 1930s found Jernagin in larger leadership positions. He served the National Fraternal Council of Negro Churches, energizing its agenda to a direct action, lobbying agent and clearinghouse for the black church. He continued to campaign for social justice through the press, protests and in the pulpit. Those three venues provided him an opportunity to be seen and heard across the country. His forceful agenda resulted in the formation of the Washington Bureau of the Fraternal Council. His Washington Bureau situated him at the epicenter of the proto–civil rights movement, establishing a blueprint for future Baptist-led civil rights leaders. He served as the face and voice of the movement; however, his inter-generational appeal and connections in Baptist/Protestant circles and social and fraternal organizations positioned him to politely promote the urgency of the demand for civil rights.

The 1940s witnessed Jernagin in his eighties applying to serve as a chaplain. He recalled the abuse black servicemen had encountered in World War I. The nature of Jim Crow no longer manifested itself overtly on southern trees but in insidious antagonism resulting in a range of abuse from mental/physical harm to dishonorable discharge. This would be the last time black servicemen would be disregarded. Jernagin dedicated his missionary zeal as a panacea for the servicemen. The solution to racial hatred was love, as exemplified by Jesus Christ. Only Christ could change the hearts of rabid racists; only Christ would provide his believers the strength to endure degradation at home and abroad. The black servicemen needed black chaplains who knew their dual struggle with exported and tacitly supported segregation in the armed forces. Jernagin journaled his missionary journey in *Christ at the Battlefront*. He applauded the servicemen, listened to their complaints and informed them of developments at home. The Double-V campaign of victory at home and abroad required both groups to keep their eyes on the long–sought after prize. The prize was civil rights, including economic, political, social and industrial parity—in brief, full citizenship for black America.

EMANCIPATION DAY: A CALL TO ORGANIZE

On January 1, 1934, Jernagin delivered an Emancipation Day address titled "New Freedom" from the pulpit of Ebenezer Methodist Episcopal Church. In Washington, the celebration of emancipation held a prized position in the community. The history of being emancipated first during the declaration issued by President Lincoln positioned them in a place of leadership locally and nationally. In April 1862, by an act of Congress, slave owners were paid to release their property from enslavement. Early freedom attracted free blacks to the area as well as allowed those newly emancipated to open and attend schools. "The large number of schools created a well-educated African American community [and varied occupations because the push for education] encompassed both traditional school-based learning and nontraditional, culture-based knowledge."[39] To commemorate this experience, the black community held formal church services, orchestrated parades and held concerts. The parades slowly were constricted by shifting zoning laws. There were historic churches that kept the tradition viable; however, when integration happened in the 1950s, the celebration collapsed into general Negro history. This situates Jernagin's address within the tradition of agency expressed by Washingtonians in general and his generation in particular. In his address, he focused on the youth:

> *Young people of our group are forgetting the past of their people, just as those young people in Jewish history forgot the God of their fathers. It is only through reminders, like this occasion, that the story is kept before them and they are made to realize the blessed assurance that our path has a guide and our eyes a light.*
>
> *Amidst the terrorism and mob violence breaking out over the land, we have just witnessed in Loudon County, Virginia the evidence of the majesty of the law and the power of guarantees written into the Constitution of our country in blood and sacrifice. Due process of law was shown to one who was marked in his color as belonging to that group coming last into full citizenship. Except the selection of the jury, his racial origin did not once enter into the proceedings in the defense of his life. Virginia has traveled far since 1619, when it made members of that same group into slaves with no rights, and held them so until forced to recognize their freedom, by defeat at armed rebellion after 250 years. It is deplorable when the demands of the present hour crowd out those records of a people's past...As our young people have forgotten and neglected that past, they also have lost that*

spiritual touch and reverence in the rendition of the spiritual songs which are their heritage.[40]

Jernagin implicated those who "counsel to forget the past" as unconvincing:

So long as we have the badge in our faces, and centuries will pass before we lose that, if ever, we shall remind mankind of that lowly state from which we have, through the mercy of God, had opportunity to rise…Race progress must be built upon racial self-respect. But racial self-respect cannot be built upon anything but racial history. Down the corridor of time, we find every people in a lowly state at some time…We do not rejoice in slavery, but in the Emancipation which came out of it, and since we know that God has allowed it, the benefit is there also…it was the work and death of two hundred thousand brave black soldiers in the Union army that turned the tide and paid the sacrifice in blood and tears, added to the groans and prayers of the faithful, which set us free. The Emancipation of four million people of African descent was not by might, nor by power, but by the spirit of freedom which Christ set loose in this world when he lived and taught and died to prove man's kinship to God.

There have been 3 great emancipations—That of the body, that of the mind, such as come from schooling and finally that of the spirit when we know we are free of fear because we know the eternal truth which is God revealed through Jesus Christ…God is not mocked, neither will He keep his anger forever, and as we arrive at the full stature of citizenship and the knowledge of the privilege and duties of the suffrage we shall assume that right and its obligations as is being gradually proven in every section of this land.[41]

Jernagin utilized this moment to teach on aspects of political history. President Lincoln, he asserted, was appointed for the cause of freedom; however, his tragic end signaled the end of his work. Jernagin noted that the idea of freedom started in 1619, when the first Africans arrived, because sin and slavery carried their own condemnation. During its infancy, Christians were at work to end enslavement; however, greed prevented it, and the power given slaveholders through their property made it legal through enacting favorable laws. He surmised, "Christianity supplied the fire and zeal; greed supplied the motive; war the occasion and political expediency, the action. Man's extremity was God's opportunity."[42] He impugned white scholars. "Though idiots" who purport this is a "white

man's country," they need to know that black men and women helped make it, defend it and save it.

He closed his address with a call to action and organizing. The freedom of a human soul dictates that desire for full citizenship and will with Christ assure that promise:

> *He must find himself politically, industrially, socially and economically and it must be done by forces within and against forces without…the end is not yet, nor are the ends reached as ideal as we would have them, but by the Grace of God* [we] *will have them. Politically, we have too often been the football or the ignorant or willing dupes of those who loved power. Only recently has the United States Supreme Court granted to us the right to enter Democratic primaries where election means office. Laws drawn to take advantage of our lack of political wisdom still remain on the statute books of many states, when it suits the will of those who love power. Political emancipation is sorely needed, and it too must and will come by striking the blow through leadership and organization among us.* [43]

Loretta Carter Hanes, a member of Mount Carmel, continued to celebrate Emancipation Day for years after the parades and public programs stopped. In 1954, she and her husband, Wesley, hosted neighborhood children in their home. The children were tutored in reading, writing and math. Wesley managed a neighborhood baseball team. The Haneses were devoted to living out Emancipation Day in every way, formally and informally. Journalist Courtland Milloy reported that Hanes explained her devotion: "When I was 5, a man we called Brother Jordan, who was 105, would stop by our house and bring my brothers, sisters and me sweet potatoes for treats. We'd sit at his feet and listen to his stories. He'd always end by saying, 'Children, you've got to bring others across the bridge of life.' And I'd say, 'Yes sir.' Although I didn't know it at the time that was my calling: to be of service to others." [44] Toward this end, in 1966, she co-founded Reading Is Fundamental, a volunteer-operated book giveaway/literacy program. Her childhood influences—including Jernagin—took root in her life.

Jernagin's address provided a tangible moment when he invested in the youth. His new position within the NBC placed him at the helm of the educational direction over at least 100,000 black Baptist youth. These youth were surrogate children and grandchildren who needed impartation of history and wisdom. Their future, overshadowed by enslavement and segregation, would involve increased understanding about Europeans,

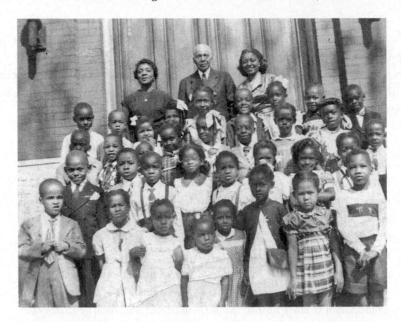

Top row, left to right: Ethel McLaughlin, Jernagin and Loretta Carter Haynes. *MCBCA*.

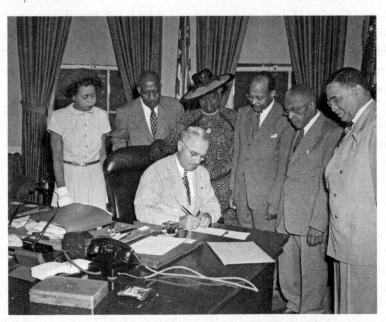

President Harry Truman proclaimed February 1, the anniversary of the passage of the Thirteenth Amendment to the Constitution (which outlawed slavery), as "National Freedom Day." Looking on are (left to right): Mrs. Harriet Lemons, J.E. Mitchell, Mary McLeod Bethune, E.C. Wright, Jernagin and Elder Michaux, 1947. *Bettman/CORBISS*.

Africans, Asians, politics and economics. Jernagin knew the skillful interplay of the "how" and "why" behind these concepts would place black people at the table of human dialogue as equals or inferiors. His life was dedicated to racial progress, and his Christian charge emboldened to accomplish that task.

NATIONAL FRATERNAL COUNCIL OF NEGRO CHURCHES

In 1905, at the Interchurch Conference on Federation, thirty Protestant denominations met and adopted the constitution of the Federal Council of Churches. The intention of the body was to form a fellowship and universal unity among the various expressions of Christianity in America. They believed that through unity the message of Jesus Christ is manifested to enhance each denomination and America as a country.

A Statement of Its Plan, Purpose and Work, a publication of the fledgling FCC, asserted that, unlike earlier ecumenical groups, it sought unity for service to mankind. In 1908, the Federal Council of Churches was formed. It crafted various departments, such as church/social service and race relations. These two departments would foster goodwill along regional, class and color lines. During the course of its life, the FCC aided in labor disputes, contributing its voice to a higher living wage, child labor laws and Sunday labor laws. Jernagin and other black ministers representing mainline denominations affiliated with the FCC. The goodwill intended by the FCC fell short on pushing for change regarding race relations. The FCC did not support anti-lynching initiatives or legal punishment for white supremacists or their acts of terrorism. Its indifference mirrored the unseeing eye of federal government officials.

In 1933, Bishop Reverdy Ransom of the African Methodist Episcopal Church (AME) issued a call to black ministers to attend a meeting to access and possibly create their own organization. "Impelled by a deep sense of the need of our racial group for an authoritative voice to speak for us on social, economic, industrial and political questions and believing that a united Negro church could best supply this need, a number of interested churchmen met in Washington and bound themselves together in what they designated as a Voluntary Committee on the Federation of Negro Religious Denominations in the United States of America."[45] Ransom was not the first to issue a call for unity; Howard Thurman held a successful meeting in 1927 but failed to capture the numbers needed to form an organization.

Thurman's National Inter-denominational Ministerial Alliance is evidence that interest existed and something within the race needed to be done.

Reverdy Ransom was born on January 4, 1861, in Flushing, Ohio. His young life was a confluence of war, racism and poverty. His childhood experience recalled a tenacious mother and the indomitable AME Church. At the age of four, his mother and stepfather brought him to the AME Church, which provided a racial consciousness and Christian stirring for a better life. "For Ransom, the connection between the church and racial justice became more concrete and he became more familiar with militant church leaders such as Daniel Payne and Henry McNeal Turner, two prominent AME Bishops."[46] Similar to Jernagin, the church and the black press contributed voice and means to express Ransom's proud black views on life, politics, culture and affairs of the day.

For Ransom, the AME's *Christian Recorder* published militant editorials that reflected the realities of his young life in border state Ohio, where southern aggressions were woven into pockets throughout the state along with the AME presence at Wilberforce University under the direction of the erudite Bishop Daniel Payne. Conversely, the legacy of Bishop Henry McNeal Turner prompted Ransom to espouse the belief in black self-defense. Black people did not need to be on the offensive, but they needed to defend their right to exist in the face of wild brutalities inflicted on them. He believed that blacks had to "exercise every God-given instinct of self-protection" and refuse immediate concession. The defensive posture needed Christian principles, protests and legal remedy.

Ransom graduated from AME's Wilberforce in 1886, and his first pastorate urgently concerned him with the overall welfare of the race as a whole. By the 1880s, he had encountered Ida B. Wells-Barnett in Chicago, who implored him to move the ministry beyond Sunday sermons and social welfare to social reform. Wells-Barnett linked "spiritual salvation" to social equity and justice. The larger social gospel movement believed that Christians had a responsibility to usher in a moral sensibility to all parts of a man: mind, body and soul. Spiritual salvation was moot when housing and employment, education and healthcare, crime and punishment were misaligned and improperly distributed. Prior to the National Fraternal Council of Negro Churches (NFCNC), Ransom waged an internal struggle with the expectations of AME leadership and the needs of working-class black people. He attended the Baptist Young People's Union and openly entertained young radicals A. Philip Randolph and Hubert Harrison.

The inaugural meeting of the National Fraternal Council of Negro Churches was held at Mount Carmel Church. In attendance were representatives from three black Methodist churches and the NBC members from the FCC. The second meeting, held in Chicago, formally organized the NFCNC. There were six chartering denominations: two Baptist, one AME, one AME Zion, one Christian Methodist Episcopal and Union American Methodist Episcopal. The NFCNC decreed:

> *While not acting under the authority of our different communions, we as officials and leaders feel that the present plight of our race in this country calls for united strength, wisdom and influence of its religious leadership. We propose that the Negro religious denominations shall cooperate on all questions touching the spiritual, moral, social, political, economic and industrial welfare of our people. It is agreed that Negroes in other communions may come and cooperate on an equal footing.*[47]

They acknowledged that doctrinal differences would not be aired through the NFCNC. They sought unity in purpose and action on behalf of the race. Social action and racial justice were the objectives through the power of unity and with the leading of the Lord. There were competing interests from white Methodists who established the Central Jurisdiction to unify black congregations in the Methodist Episcopal tradition. Concurrently, there was Marcus Garvey and his Universal Negro Improvement Association (UNIA), whose religious department appealed to ardent nationalists. The NFCNC provided an alternative forum for clergy who rejected the extremes of the UNIA and paternalism of white parent denominations yet desired to criticize and protest American indifference in concert with others of the Christian faith.

The birth of the NFCNC during the Great Depression accelerated its urgency to advocate for black people. The "twin scourges" of poverty and racism were evident throughout the country in rural and urban communities. In August 1935, the group issued its first public statement: "A Message to the Churches and to the Public." In this address, it proclaimed a self-determined effort for unity in the wake of a history littered with enslavement, division and antagonism:

> *The hour is at hand when the Negro church should unite to fearlessly challenge the faithless stewardship of American Christianity by submitting it to the test of political, social and economic justice that accepts no peace on the basis of submission, compromise or surrender. Shall the American*

Negro, whose broadest boast is the patriotic devotion and loyalty with which he has defended our flag in all wars, be less devoted and loyal to the cross of Christ when all that it stands for in human relations is either openly denied, menaced, in social, economic and political denial with which it is flouted or assailed?

Those who have joined the [NFCNC] *have found joy in the larger freedom and fellowship. We call upon ministers and lay members in the churches to cross the boundary lines of their denominationalism to join in the common task of working in the present to secure the future peace and justice not only of our race, but of all underprivileged and oppressed.*[48]

This statement spoke to the frustrated experience black ministers encountered in bringing America into remembrance of its biblical foundation. Moreover, it challenged the silence and indifference white denominations employed when matters of equity for black citizens were denied, violated or ignored. The message communicated the passion of Jernagin and Ransom, both born in the Civil War era. They knew of enslaved people, heard their stories and witnessed their efforts to build lives for themselves after emancipation. These men were in their sixties, with more years behind them than ahead of them. Their lives and present efforts would decide the fate of the race in terms of its moral foundation and social destiny.

The NFCNC employed strategic aims throughout the country to bring about attention and change to injustice. From 1934 to 1950, there were meetings, newly elected leadership and growth. Jernagin served as president from 1938 to 1939. He served on the executive committee as chairman from 1940 to 1945 and 1952 to 1958. He created a Washington Bureau Committee, which operated along with the other fifteen NFCNC committees. In 1943, Jernagin separated the Washington Bureau into a semi-autonomous group while serving as chairman. Unfortunately, conflict arose, resulting in Jernagin resigning in 1947. He remained an advisor to the Washington Bureau. In 1952, he regained the chairman's position until his death in 1958. "With both the Washington Bureau and the executive committee under his command, Jernagin in effect *was* the NFCNC."[49]

Jernagin's leadership style differed from Ransom's. He wanted pragmatic activism, while Ransom opted for public pronouncements. Jernagin's location in Washington, power within the NBC and personality of direct engagement launched the Washington Bureau into the forefront of the proto–civil rights movement. His Washington Bureau served as the de facto voice of the black church on executive and legislative matters in the struggle to

secure civil rights. Jernagin's connections—established in a variety of forms, including local, national and international; Christian, activist and radical— culminated in a whirlwind of activities from 1943 to 1958 contributing to the urgent demand for civil rights. "[The Washington Bureau] staff met and corresponded with presidents Roosevelt to [Eisenhower]; testified before House and Senate Committees on such issues as the FEPC, anti-lynching and anti–poll tax bills, desegregation of interstate travel, housing and education aid, civil rights for [Washington] and the 1957 Civil Rights Act."[50]

The Washington Bureau became engaged in World War II efforts, offering its services as chaplains to Negro troops. This campaign, reported in the black press, linked the heroic efforts with the homefront's Double-V campaign for victory at home and abroad. On January 7, 1948, four hundred ministers held a prayer vigil on the east steps of the Capitol for the passage of anti-lynching and civil rights legislation. They convened at Mount Carmel, marched to the Capitol and returned to Mount Carmel to hear reports on the status of congressional progress pertaining to anti-lynching, civil rights, fair employment practice, anti–poll tax and other civil rights legislation. The closing prayer offered that day read:

Our Father, the Father of all mankind: We come to this place today in Thy Holy Name. We come in sacred memory and deep gratitude for Thy goodness and mercy to us as a nation. Thou hast protected, promoted, and exalted this people, and permitted them to grow and prosper and sit in high places among all the nations of the world.

Thou hast permitted them to extend commerce and fight for their own security. And now, O God and Father, we pray Thee to give this people a burning desire to build Thy Kingdom in the hearts of men and to make brotherhood real in this land and in all lands. Help this Christian Nation to glorify the things of the spirit. Help us to forget race and creed—help us not to depend on material things for power. We need Thy protection and Thy guidance. Humble us in heart. Give this people the spirit of service, and of righteousness so that this nation can endure. We beseech Thee to teach all nations how to make wars to cease. Give clear vision, divine guidance, and direction to the men and women who occupy places of leadership and responsibility.

Help our Congress, now assembling, to consider grave and far-reaching questions, not to become a house divided against itself on questions that make for justice, progress and peace. Help them to find a way to outlaw mob murder. Help them to enact laws that shall give to every man, woman, and child in this nation equal opportunity for education, work and protection, under the law.

> *And now, O Father, we lay our petition before Thee, and beg that Thou wilt purge this whole nation of injustice, hate and greed. We pray for the longsuffering, patient toilers who live in darkness and despair amid dangers and difficulties that wound their souls and break their spirits. We pray Thee to help us to lift this whole nation by Thy grace, and truth and love. Help us to speak The Word of Life and work together for peace on earth and goodwill toward men. In Jesus Name, we ask these blessings, and the forgiveness of our sins of omission and commission.*
>
> *Amen.*[51]

The Washington Bureau orchestrated two national prayer marches, one on behalf of World War II servicemen and the other in anticipation of civil rights legislation. In September 1954, it sponsored the Lincoln Thanksgiving Prayer Pilgrimage held at the Lincoln Memorial. The Thanksgiving Pilgrimage was scheduled in celebration of the first Emancipation in 1862 and in honor of the unanimous Supreme Court decision in *Brown v. Board of Education.*

The third Washington Bureau sponsored a National Day of Prayer on May 17, 1957, for the Montgomery bus protest in Alabama. The event raised several thousand dollars. Martin Luther King Jr. delivered remarks at this gathering:

> *Three years ago the Supreme Court of this Nation rendered in simple, eloquent and unequivocal language a decision which will long be stenciled on the mental sheets of succeeding generations. For men of goodwill. It came as a great beacon light of hope to millions of disinherited people throughout the world who had dared only to dream of freedom. It came as a legal and sociological deathblow to the old Plessy doctrine of "separate-but-equal." It came as a reaffirmation of the good old American doctrine of freedom and equality for all people.*
>
> *Unfortunately, this noble and sublime decision has not gone without opposition. This opposition has often risen to ominous proportions. Many states have risen up in open defiance...Methods of defiance range from crippling economic reprisals to the tragic reign of violence and terror. All of these forces have conjoined to make for massive resistance.*[52]

Dr. King's speech contends that black people have the natural ability to decide for themselves just laws; however, they are prevented from exercising that right in the South. Violence and intimidation were used to thwart

attempts to participate in the electoral process. He argued, "Give us the ballot and we will transform the salient misdeeds of blood-thirsty mobs into the calculated good deeds of orderly citizens." The vote needed security from strong leaders dedicated to equality unbought, unafraid and full of integrity. This leadership, King asserted, needed to be in the hearts of whites and blacks alike. He closed with a call to rational interracial cooperation:

> We must work passionately and unrelentingly for the goal of freedom, but we must be sure that our hands are clean in the struggle. Let us never become bitter. We must act in such a way as to make possible a coming together of white people and colored people on the basis of a real harmony of interest and understanding. Let us realize that as we struggle for justice we do not struggle alone, but God struggles with us. He is leading us out of a bewildering Egypt, through a bleak and desolate wilderness, toward a bright and glittering promised land.[53]

E. Pauline Myers authored *Hands Across the Table*, a pamphlet that celebrated the accomplishments of the Washington Bureau. Myers is listed as administrative assistant for the Washington Bureau; however, she was much more than a secretary. Myers was described as a foot soldier in the early efforts to desegregate the armed services. Her activism never positioned her in the limelight of a high-profile leader, but her service and contributions to various groups laid the groundwork for the civil rights movement. She was an aide to A. Philip Randolph, a member of the NAACP and a Civilian Conservation Corps worker. In 1941, she helped Randolph organize the March on Washington for National Defense Jobs, a threat that Roosevelt quelled with legislation. Her work with the NCFNC included conducting legislative training workshops, organizing domestic workers and documenting evidence to support desegregating the military. She was a graduate of Hampton and Howard Universities. In *Hands Across the Table*, Myers opens with an introduction to the NFCNC's desired goal:

> The [NFCNC], in constituting the Washington Bureau clearly challenges us to adopt a bold and aggressive program dealing with the injustices that are in existence within our nation. Negro Churches of all denominations can unquestionably unite on a nation-wide program of better understanding of the issues for which we fight and consolidate their resources, moral, spiritual and financial for a drive to end the undemocratic and unchristian

conduct practiced against members of our group by certain segments of the dominant group.

The war which is being fought for the peoples of democratic principles focuses attention on the undemocratic practices existing outside [our] own country. Color caste is becoming an expensive luxury for the white man. It has demoralizing and hate-producing effects. It plants fear and suspicion in the minds of men and is rapidly sowing the seeds that will lead to the destruction of the established order and to [World War III].

The Negro which is emerging out of [World War II] is rapidly reaching his maturity. He is aggressive, resolute and determined to be free. The Negro veteran having faced death on foreign battlefields in a war alleged to be fought for the democratic ideals of freedom and equality will not tend to accept happily the caste of second class citizenship. The army has been no moral institution. The Church, community and the government must begin to plan now for the return of G.I. Joe.

The usual search for a scapegoat, identifying it with a minority group, has fostered anti-Negro strikes, race riots, and lynchings and increased the insecurity of the 13 million Negroes residing in [America].

All this indicates an unexploded bomb in our midst which calls for a united program of study, understanding and action.

The Washington Bureau seeks the support of Churches of all denominations in a concerted effort to bring about legislation designed to benefit the great mass of American people with special privileges for none.[54]

Myers portrayed the Washington Bureau as a clearinghouse dedicated to the civil rights movement. She documented its effort to amend the Dumbarton Oaks Charter. She noted that through the relentless pressure of Jernagin, the State Department broadened its admission policy, allowing representatives from the Washington Bureau. The representatives were Dr. Mordecai Johnson, Howard University; Reverend J.L. Horace, vice-president, NBC; and Dr. H.T. Medford, secretary/treasurer, Foreign Missions AME Zion Church. The representatives delivered a petition of six items that were added to the larger petition of the American Delegation at the United Nations' Conferences. Of note are those international interests that augmented the call for civil rights at home:

[1] *We demand an end to the imperialism and colonial exploitation of the Western Empires and urge immediate independence for India and Puerto Rico…*[4] *We further urge a united Colonial Charter for Colored peoples*

of the world, guaranteeing equality of citizenship regardless of race, color or creed.

A. Color bars should be declared illegal in [America], Great Britain and in the colonies.

B. Any direct or indirect limitation of privileges for citizens on account of their race or nationality as well as any propagation of racial or national exclusiveness or hatred and contempt should be made punishable by law. [5] We oppose what seems to be a power Alliance of the Three Great Powers who by virtue of their Armed might threaten to coerce the rest of the world into submission. We regard it as a menace to future peace and to world security. This implies an imperialism that must of necessity lead to [World War III] in the next generation...International conflicts must be dealt with before they reach the danger stage. We have a responsibility as Christian citizens to work for these humanitarian goals.[55]

Jernagin's testimony before the Subcommittee of the Committee on Education and Labor in the U.S. Senate appears in the appendix of Myers's pamphlet. His statement is an eloquent discourse on the need for passage of the Fair Employment Practices Act:

I shall speak far less, I trust, as a Negro than as a representative of the Christian Church whose duty it is to uphold the Christian ideals and to work for their realization with the belief that the conventions and customs of society can be changed by the persistent pressure of Christian influences. As churchmen, we have respect for government and believe that reasonable, intelligent administration can achieve results "if the spirit is right."

At this hour of crisis the church is concerned specifically with economic distress which deepens as the world crisis develops. When the war ends jobs will disappear for from one to twenty million workers in war production in [America]. It is needless to say, minority groups will suffer most due to manpower surplus.

There is no hatred and strife bitter than that which can come when people of different races compete for too little food and too few jobs. We would be morally derelict in our Christian duty if we failed to call attention to the unethical basis of an order which permits this kind of distress to continue. The church must exert its influence to eliminate the causes of economic distress and also to help to set in motion those administrative and legislative measures which must be taken as a preliminary to the establishment of a just social and economic system.[56]

Jernagin indicated that others such as Asians, Catholics and Jews suffered discrimination. Therefore, the post–World War II conditions needed consideration because the overt vertical racial dynamic could inflate the numbers of discontented people to eclipse the white majority. The federal government needed to lead the way in economic security. He stated, "We cannot expect one individual employer to have the moral integrity to stand out against or defy an unjust economic system when our Government and its lawmakers lack the moral courage to resist it or to establish any laws to abolish this discrimination."

Jernagin positioned himself as an apostle of reason and prophet of consequence:

> *I speak not only for the "gentlemen of the cloth" but also for the 6,000,000 or more Negro worshippers who make common cause with us and who look to us for spiritual guidance and Christian statesmanship. The awakened masses of our people have begun to rise and demand their democratic rights. The church is called upon for greater faith and greater courage than it has ever need before.*
>
> *It is the feeling of the church that our Government must have the moral courage to set in motion that kind of political and economic machinery that will enable all its citizens to have the right to life, liberty and the pursuit of happiness.*
>
> *We cannot continue to accept this discrimination and degradation even though submission to it seems to have certain initial advantages and resistance may bring suffering upon us. But neither can this Government continue to permit practices of discrimination that have brought not only us but white men as well to this sorry pass and the continuance of which can only lead to greater woe. The situation must be met frankly and squarely.*
>
> *Let us then face our common problem together, both church and Government, each of us having the courage to meet opposition with love and with the determination to build a new America in which you and I may stand and walk as free men in a free country. As professed Christians, can we not break over the boundaries of race and act in the spirit of common brotherhood?*
>
> *We want to take the opportunity to commend this committee and its chairmen for the magnificent spirit with which it is conducting these hearings. The Government in some way or together must take a firmer stand than ever before, because these millions of Negroes that have had such strong faith in the Government are looking to their own Government, that*

they have never betrayed, to come to their rescue and not allow conditions as they are to continue when it comes to their rights as American citizens.[57]

Senate bill 2048 passed. In 1941, Roosevelt issued executive order 8802 banning discrimination in the defense industry.

The Washington Bureau also expressed support for King, his cadre of leaders and those dedicated to ushering in social justice. On July 12, 1957, King, president of the Montgomery Improvement Association, penned a letter to Jernagin. The letter came in the wake of four church bombings, the result of ardent racists who resisted the rising tide of civil rights demands from African Americans fed up with discrimination, violence and Jim Crow. Dr. King wrote:

> *This is just a note to acknowledge receipt of your very kind letter of June 28, with the enclosed check of $1,200.00 to be used for the reconstruction of the four bombed churches in Montgomery, Alabama. Words are inadequate for me to express my appreciation to you and the officials of the Congress for being gracious enough to take this offering...It was a real pleasure being with you in Dallas and being a part of our great Congress. Thanks again for all of the interest that you have taken in our struggle and the encouragement that you have given me personally. May God continue to bless you in all of your endeavors.*[58]

Jernagin understood the benefits the NFCNC offered the growing civil rights movement. The unity, powerful network and economic power leveraged the physical cost of those sacrificing themselves in activism throughout the South. Unfortunately, internal tensions within the NBC and the increasing physicality of the civil rights struggle in the Deep South coupled with the death of Jernagin rendered the NFCNC anemic.

In 1959, Andrew Fowler served as the director of the Washington Bureau. Mentored by Jernagin, he continued to live out his vision of a full-press strategy for civil rights and justice. Fowler utilized the Washington Bureau to provide that voice of advocacy for local issues as a minister, resident and parent. Jernagin charged Fowler to keep the Washington Bureau solvent. "He kept [it] out of debt, and continued to lead the organization into the 1960s and 1970s [parallel to King's SCLC]."[59]

NATIONAL NEGRO CONGRESS

In May 1935, a conference called Economic Crisis and the Negro held at Howard University resulted in the formation of the National Negro Congress (NNC). The conference produced documentation that the Depression and its projected recovery would force African Americans into further economic strain and lower socioeconomic positions. The NNC would provide public education and policy advocacy to stem the tide of this devastation. It would accomplish this mission through being a confederation of organizations seeking to address economic disparity. The 1936 meeting officers were elected: A. Philip Randolph, president; John P. Davis, executive secretary; Marion Cuthbert, treasurer; and Joseph Evans, assistant treasurer. The aim of the NNC was to develop an orchestrated protest against Jim Crow norms and mores. Jernagin attended the 1936 meeting. The underlying tenet of the NNC was economic parity. NNC members would educate business and industry that black people were a viable segment of the American economy. There were seven immediate concerns of the NNC:

1. Find employment with a living wage
2. Desegregate trade unions
3. Aid and support black farmers
4. Stop illegal mob violence
5. Secure the franchise
6. Protect the rights of women and children
7. Actively oppose war literally and intellectually

These seven points wedded the theory generated by the Howard faculty into practical applications for membership and their organizations. Randolph's ideas guided the organization. He believed that constant struggle was the surest means to securing justice and freedom. Jernagin served as an officer in the Washington branch of the NNC. The group's desire for direct action and intergenerational cooperation suited him. Jernagin utilized the scholarship of the members to write to President Roosevelt about the implementation of the Fair Employment Practice Commission (FEPC). Roosevelt was willing to work with black leaders in exchange for support. In 1941, the NNC called for anti-Hitler mobilization. It viewed Hitlerism as akin to Jim Crow. On October 17, 1941, the *National Negro Congress News* issued a press release titled "Fifty Negro Leaders Call Anti-Hitler Mobilization Conference in Nation's Capital." Jernagin informed readers that "it is high time that we mobilized all of our organizational forces and every segment of the Negro population for all-out action for the defense of democracy and the

defeat of fascism. It is our task to rally our Negro community to the support of the President's policy and to strengthen our people's understanding of the issues so that they may not be deluded by arguments of the appeasers."

In November 1942, a letter from Max Yergan to Jernagin stated: "You demonstrate by deeds the kind of fighting spirit which is needed in our country's critical hour to unite Negro and white Americans for victory over the Hitler Axis. In the name of the Congress we express to you the wish that you will enjoy many more years in the service of the people of your church and people of the Nation." The NNC withered as the organization's direction meandered between policy and protest. Many defectors left and joined labor unions, and most others departed after the House Un-American Activities Committee (HUAC) branded the NNC a subversive group. In a letter on June 11, 1951, Jernagin responded to the investigators:

> *I need not say to you that I was shocked to learn that these organizations are regarded as "Communist Front" organizations. I wish to assure you that I have never intended or desired to be associated with any organization whose purposes and objectives were in opposition to the fundamental principles upon which America was founded. For years I have dedicated my life, as a minister of Christ, to the cause of human justice and equality of all men regardless of race, religion, color or national origin.*
>
> *I was an active participant in the [NNC] for some time, until about eighteen years ago, at which time I severed my connections with it because I had reasons to believe that it was being dominated by Communist influence. As a minister of the Gospel of Peace and Brotherhood, I'm sure that the young people of America, as well as the Christian Church and I believe the leaders of America will expect me to continue to work for such a cause. I wish to assure your committee and the entire American people of my undeigned devotion to the principles of our Constitutional Government, to which I shall ever remain loyal.*
>
> *In making this statement, I do not wish to be understood or to imply, that I shall cease to do legitimately and in good conscience whatever I can for the cause of Peace and brotherhood, as God shall give me light and guidance.*[60]

In the end, the NNC served a purpose. The inter-organizational cooperation allowed for forward movement and public education. The NNC agitated for full citizenship with economic parity to link citizens to a sense of renewed nationalism. The *Chicago Defender* cited the NNC as the most ambitious effort to bring the race together on any single issue pre–

World War II as attempts for justice and freedom accelerated the day of civil rights for all Americans. In 1947, the NNC disbanded, in part due to HUAC investigations and dwindling membership.

RACISM ON THE RAILWAYS

Jernagin preferred to convert differing ideologies through persuasion; however, if unsuccessful, he had no problem with direct engagement. On January 4, 1947, in an article for the Baltimore *Afro-American* titled "Church Leader Expresses Belief New Congress Will Enact Liberal Legislation," he wrote:

> *We must realize that this progress we desire will be won only through direct friction and elimination. The very illegal methods of voting and disfranchisement which brought these men into office are now under close scrutiny by the government and the nation as ever before...The two greatest achievements by colored Americans during the past year which I consider most helpful in advancing the cause of Americans are: the recent favorable decision by the U.S. Court of Appeals in the suit brought against the Southern Railroad by Ralph Matthews, William Scott and Jernagin. The decision makes the railroad definitely responsible for maltreatment of its colored passengers who travel in coaches in interstate travel. This is the first time a high court has ruled on an issue which so favorably affects the respect for our civil rights in interstate travel on coaches.* [The second achievement is the] *issuance of the commemorative Booker T. Washington coin...This is a tangible expression of the progressive forces in our Congress to recognize and evaluate the achievement of a Negro in democratic terms.*

The lawsuit against Southern Railway directly involved Jernagin, Scott and Matthews. The men purchased their tickets in Philadelphia for passage to North Carolina for church business. They boarded the train in Philadelphia and passed through until they were asked to move seats after arrival in Charlottesville, Virginia. They inquired why and were told they were entering a region of the country that dictated segregation, requiring them to occupy the reserved car for black passengers. The men refused. Train officials notified the Lynchburg police, and the police

officers asked them to move. They refused and were forcibly ushered off the train.

During the trial, the train and police officers claimed they were following the law pursuant to the Virginia statute that required railroads operating in the state to furnish separate cars for white and black passengers. Failure to comply by refusing or forgetting to enforce the law was a misdemeanor for any company or person. Jernagin's lawyers argued that the state law was invalid for interstate passengers and inapplicable to this group. The issue before the court was whether the police officers were acting as an extension of the Southern Railway company and therefore liable. It was decided they were, in fact, liable and violated the civil rights of Jernagin, Scott and Matthews. The Fourteenth Amendment assures all citizens the right of equality in accommodations and equal protection under the law.

The men had purchased first-class tickets and refused the substandard accommodations of segregated passenger cars. Jernagin's lawyers understood the gravity of limiting black travelers while extorting full fares. On January 23, 1944, in the *Atlanta Daily World*, attorney Richard E. Westbrook stated:

> *If democracy is to be sustained and the constitution and laws upheld such unjust discrimination against American citizens traveling in interstate commerce must be vigorously prosecuted. It should be of no consequence that criminals are powerful railroad corporations or whether they be citizens without money and without power, an equal enforcement of the law against all criminals' consonance with the oath of office of the executive administrators of the law. Thousands of American citizens of color are sacrificing their lives all for democracy. Can this great [country] preserve democracy at home? [Jernagin's] experience with the [Jim Crow] laws of the south is just another example of the abuse of state's rights. The legal yoke employed by southern states to persecute colored citizens.*

The long history of public embarrassment and physical abuse endured by black people riding across state lines figured prominently in the civil rights movement. Jernagin's case exposed the insidious nature of state laws that sought to circumvent federal laws. Moreover, the train company acquiescing to the state to avoid being fined made it a willing participant in denying black citizens their civil rights. Jernagin, Scott and Matthews suited for a total of $45,000. Their victory was another deathblow to the monster of state-sanctioned segregation.

MARY CHURCH TERRELL, JUSTICE AND LOCAL PROTEST

Mary Church Terrell came to Washington in 1889. She came from an established family in Memphis and accepted her social obligation as a woman with means. Her politics were not paternalistic; she was progressive yet conservative. Her generation employed respectability as a means to reimagine the idea of black citizenship in the eyes of white people. The moral and respectable lives of black people would knock down racial barriers. A well-heeled black person was more potent than protests or armed movements. Terrell's politics would change as the retrenchment of segregation disregarded every well-intentioned move of respectable black people. Washington proved a microcosm of American racism. There were no lynching victims on trees, but there were policies and de jure norms that were equally murderous. When Jernagin arrived in 1912, he would find Terrell a notable clubwoman connected, educated, outspoken and determined.

Eventually, he worked with her in various campaigns to end segregation in Washington. Terrell was born on September 23, 1863, in Memphis, Tennessee. Her father's investments in real estate made him a millionaire. Fair complexioned, educated and allowed access to travel, Terrell's sense of racial pride and unity came from affronts she endured because of the virulent racism of the South.

She obtained a degree from Oberlin University in Ohio in 1884. She moved to Washington, D.C., and taught at the M Street School. Her growing awareness of discrimination propelled her to intensified study and a consummate desire to speak out on behalf of the unlettered in general and black women in particular. She was the first president of the National Association of Colored Women's Clubs (NACWC) in 1896. Crafting the NACWC into a social justice organization, she helped it create day nurseries, kindergartens and mothers' clubs. All of these efforts sought to ameliorate the harsh conditions of working-class black women. Her advocacy advanced the race and sought better opportunities for working women and rising generations of young black women. She wrote articles, lectured and protested for change. In her more than ninety years of life, Terrell did not concede to color privilege within the black community as a place of refuge from empathizing with the economically or aesthetically challenged elements of the African American community.

In 1904, she addressed the International Congress of Women held in Berlin, Germany, as part of the American delegation. She was the only

woman of color. When she arrived in Berlin to deliver her address, there had been some concern that speaking in English would lessen its impact. To the audience's surprise, she delivered her address in German. She was fluent in German, as well as English and French. An essay entitled "Emerging Women" stated:

> *This brilliant daughter of a despised race, stood in her place amid this celebrated assembly and pled the cause of her sable sisters in English, French and German, with such ease and eloquence that each delegate from those nations could hear and understand the sad story in her own tongue. The effect of one who herself had come up from lowly conditions which she so eloquently portrayed voicing the miseries and wrongs, as well as, the struggles and triumphs, of black womanhood filled every heart with pity and melted every eye with tears.*[61]

Terrell's commitment to civil rights compelled her to campaign for justice through an organization she founded, the interracial Coordinating Committee for the Enforcement of the District of Columbia Anti-Discrimination Laws (CCEDCADL). The CCEDCADL led a crusade against segregation in public spaces, in particular the Thompson Restaurant. The goal was integration in public spaces. "The CCEDCADL set the pace and the expectations that would lead to the demise of the remaining racially exclusive covenants for public facilities and ushered into full bloom the civil rights movement in the city."[62] The CCEDCADL was birthed as a result of legal research to reactivate a dormant 1872 law. The law stated, "Any restaurant keeper...refusing to sell or wait upon a respectable, well-behaved person without respect to previous condition of servitude shall be deemed guilty of a misdemeanor, shall be fined $100 and shall forfeit [their license as a restaurant]." The District government suggested that Terrell wait until the legal process rendered its decision. This response pushed her to action. First, she requested that President Truman intervene. He was silent. This radicalized Terrell, resulting in selecting a restaurant to create a test case.

In 1949, she served as president and Jernagin was vice-president of the CCEDCADL. The campaign involved protesting, picketing and crafting a test case. Initially, the three persons—two black and one white—creating the test case were "respectable" in their dress, demeanor and reputation. When they sought to eat a meal, they were denied service, resulting in a lawsuit. On July 10, 1950, Judge Frank Myers ruled in favor of the restaurant on the grounds that the 1872 was rendered void when the Organic Act established

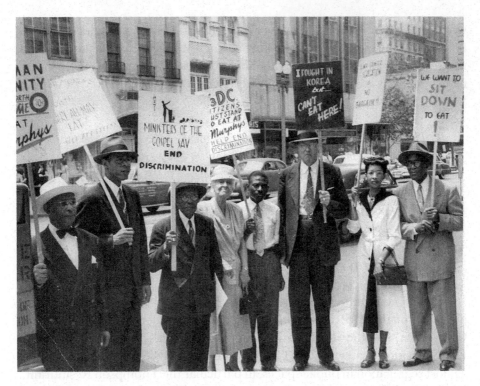

Mary Church Terrell (center with light dress and hat), Jernagin (third from left), R.L. Patterson (fifth from left) and others picketing. *Courtesy Moorland Spingarn Research Center, Prints and Photographs.*

a new form of government in 1878. He concluded that the law was "repealed by implication." Displeased with this decision, the CCEDCADL appealed. On May 24, 1951, the Municipal Court of Appeals reversed Myers's decision. The CCEDCADL victory led to increased publicity to challenge select restaurants that discriminated on the basis of race. The stores in the crosshairs were C.G. Murphy, Kresge and Hecht Company. "Terrell reported that the Yuletide boycott at Kresge had reduced their black patronage by over eighty-five percent."[63]

The victory was short-lived. On January 22, 1953, the U.S. Court of Appeals reversed the Municipal Court's judgment in a 5–4 decision. It concluded that enforcement of a seventy-eight-year-old law overstepped the boundaries of the legal authority. Washington, an occupied municipality and not a state or territory, could only exercise limited authority through its Board of Commissioners subject to federal government oversight. The CCEDCADL filed an appeal to the

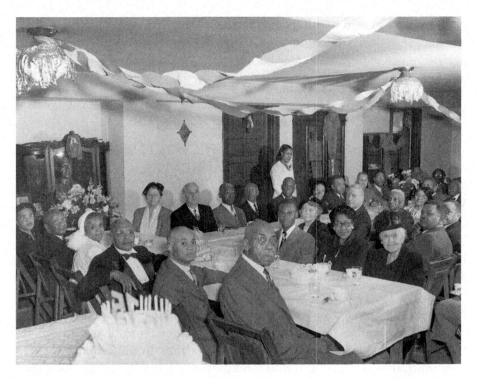

Mary Church Terrell (second row, woman on far right), Cordelia Jernagin (front row, third from left in white hat), Jernagin (to right of Cordelia) and others at a Mount Carmel church anniversary. *MCBCA.*

U.S. Supreme Court and petitioned President Eisenhower. It issued a statement: "We, the citizens of Washington, DC are sick of segregation. It is wrong and indefensible...We the undersigned, while awaiting Supreme Court Review...urge you to...ask prompt action to fulfill the president's pledge to end all segregation in the nation's capital."[64]

The Supreme Court decided that "the [act] of 1872 survived the intervening changes in the government of [Washington] and are enforceable."[65] Eisenhower used this decision to promote the Republican Party as "responsible for ending segregation in Washington." This move would attract black voters back to the party following their exodus in the 1930s. Terrell and Jernagin were both Republicans. This position outraged Terrell, who drifted away from her party and embraced a militant position. The Thompson Restaurant decision greatly contributed to the demise of public segregation in Washington. Its success lay in the leadership and their organizational networks. Terrell was well connected in numerous women's

clubs, while Jernagin had influence through the NBC and other Christian groups. Terrell and Jernagin were in their eighties when they crusaded against public segregation, contributing to the righteousness of their protest and need to remain vigilant.

OFFERING CHRIST ON THE BATTLEFIELD: SOUTH PACIFIC THEATER

War evokes a belief in God or something divine because the immediate threat to one's life is ever before one. The African American men and women who served in World War II realized the perils of war up close and personal in two arenas: the enemy inside their ranks and the enemy outside their ranks. America sluggishly emerged from the Great Depression through the matrix of social programs innovated by President Roosevelt. His measures massaged the economy through providing employment for the youth through the National Youth Administration, for those in rural areas through the Civilian Conservation Corps and for the artistic in the Works Progress Administration and its oral history and literary projects. Roosevelt was the first twentieth-century Democrat openly embraced by African Americans, and they received his consideration with the formation of the Black Cabinet. In 1939, Mary McLeod Bethune, the first African American federally appointed to administer a national program, organized the Federal Council of Negro Affairs, commonly known as the Black Cabinet. The members of the cabinet included representatives from every major department. Bethune also utilized race leaders outside the government from Howard and organizational contacts. Her intentions for the cabinet were to bring thinking people together to strategically lift black people out of underemployment and poverty through training and exposure offered by the federal government through New Deal initiatives. Bethune was born in 1875 in South Carolina. She founded the Daytona Normal School to educate young women. Her school successfully raised funds, attracting attention from blacks and whites. A chance encounter with Eleanor Roosevelt broadened Bethune's audience from regional to national acclaim. She lived in Washington throughout the 1940s to build coalitions with thinking people as well as grow her fledgling National Council of Negro Women (NCNW).

Jernagin was familiar with Bethune, and they often joined others in striking down segregationist policies throughout Washington. The war effort provided

fertile ground for Bethune and Jernagin to ensure that postwar America allowed all citizens equal access and opportunity to self-improvement from education to employment. Bethune dedicated her work on behalf of the Negro woman, while Jernagin dedicated his service to the chaplaincy.

Michael Snape in *God and Uncle Sam: Religion and America's Armed Forces in World War II* provides a picture of an America hurled into a war that did not initially concern it; however, the patriotism to provide and secure the democracy of others served as a rallying cry. Men enlisted and women beside them volunteered their talents and time to serve America. Snape notes that America has a long history of military chaplaincy; however, World War II chaplains no longer competed with well-intentioned groups such as the Young Men's Christian Association (YMCA). The presence of chaplains served political agendas, reclaiming America as a Christian country and aligning it with being on the "winning" side of truth, justice, right and divine might. This served well in media campaigns on radio and newsreels aired before feature films. Political cartoonists depicted Japan and Germany as demonic countries led by despots who deified themselves. These images stoked the embers of xenophobia, resulting in American citizens of Japanese ancestry being corralled and placed in internment communities. German prisoners of war were housed throughout military camps, where they benefited from color politics. They were treated better than the black servicemen charged with guarding them. Segregated dining areas and debasing social norms fanned flames in the hearts of black servicemen who, by nature of their military positions, obeyed orders as well as lived above the fray on behalf of the race. The black servicemen and women knew they walked a precarious line between stereotype and respectability. Bad behavior would result in a dishonorable discharge, confirm stereotypes and hinder those seeking to enter the service. Conversely, they had to endure emotional and physical abuse from within the military, throughout society and over the course of their encounters with people throughout Asia and Europe. Their success or failure would hasten or delay the call for civil rights as civilians and future service personnel.

Maggi M. Morehouse, in her dissertation "Black Citizen Solider," indicated that Roosevelt deliberately missed his moment to usher in equity for black service personnel. He appointed Benjamin O. Davis Sr. to brigadier general, the highest position attained by a black man in military service. However, for the enlisted men, he glossed over the details of black officers and black troops, holding to the segregationist model. On February 17, 1942, the NFCNC wrote a letter to Roosevelt on this matter.

It is our deep concern for American democracy that causes us to speak out against those things which hinder the full participation of the Negro in the war effort. Continued exclusion of Negro workers from employment at war production is an injury to the whole American people. The practice of segregation and discrimination in the armed forces lowers the morale of all Americans, Negro and white...In this connection it is regrettable that in a democracy Negroes should be treated without respect for the dignity of their personality and the exercise of their citizenship...Negro Americans seek only the unhindered opportunity to make their full contribution to the defense of America as is their right as loyal citizens...We call upon the President to see that the Government sets the pattern for the democratic participation of all citizens without regard to race, color or creed, in government jobs, the Army, the Navy, the Marines, the Air Corps and in all government activities...We call upon the President not only to support this ideal by Executive orders but also to make full use of his War-Emergency powers and to see that those orders are enforced...The Negro solider has always proved his courage and heroism. This is the heritage of the Negro youth. In giving their lives as loyal Americans our Negro soldiers imposed no conditions. In the support of the best traditions of freedom and democracy, we pledge our allegiance, our loyalty and our lives in the defense of the nation.[66]

Roosevelt had an administrative assistant provide the response. In brief, separate but equal is a long-standing practice established by Congress and in no need of immediate correction. Roosevelt, the skillful politician, appointed Howard University law school dean William Hastie as advisor for Negro affairs. Hastie, aware of his fawning gesture, utilized his position to bring attention and change to the conditions under which black servicemen toiled. Hastie presented segregation as undemocratic. He used letters of incidents reported by black servicemen as evidence of undemocratic practices and their demoralizing effect on the emotion of the troops. The War Department, according to Morehouse, circumvented the issue by declaring segregation as a social matter, not a military one. Army chief of staff George Marshall proclaimed that Hastie was asking the military to solve a long-standing and complicated social matter while fighting a war, which was impossible. The War Department's sole concern was fighting wars, not solving social problems, even though the servicemen and officers were products of their environments and imported their social norms into a hierarchical system that modeled racism without any reprieve for the victims and a blind eye for the victimizer.

The white officers viewed African Americans through a racist lens. Black men were aggressive and determined to stop Hitler and his white supremacy/master race ideals. The snub Jesse Owens received at the 1936 Olympics was a fresh memory. On the other hand, black men were viewed as suspicious of harboring hatred toward white Americans. Arming these men equated to training one's assassin, an idea unfounded but possible in the imaginations of white servicemen and officers. The white officers' training manual *Leadership and the Negro Solider*, according to Morehouse, warned against the tendency of African American men "shirking their duties and engaging in rumormongering." There was an entire section of the manual dedicated to rumors among Negro soldiers. The racism ideas were not new. The Christian Church was steeped in bigoted ideas, resulting in many separate congregations and denominations since the 1800s. As a result, white chaplains were usually accustomed to homogenous communities in part from their socialization and the indifference from black servicemen. Ideas of origin, capacity and tendencies resulted in the formation of three separate African American Methodist denominations and numerous black congregations of Episcopalians, Presbyterians and Baptists.

This pained many people, in particular Jernagin. The accentuated lack of democracy at home and young men fighting to have the right to fight a common enemy while pleading for their basic civil rights was insulting, yet it was a mark of African American patriotism and agency to exhibit their valor in an effort to have those rights respected. Toward this end, Jernagin decided to serve as a chaplain at the age of seventy-five. He recounted the inspiration and hope he had offered black servicemen in World War I. Once again, he could offer Christ and hope to young men risking their lives for a democratic ideal they could not fully enjoy at home. This time, the NFCNC was invited to select a representative to join a delegation touring the Pacific theater. The group selected Jernagin. His age presented a concern. In October 1945, he received a health certificate certifying him free of all contagious disease, host to no parasites and compliant in all immunizations.

The war raged across Europe, Asia and North Africa. Jernagin had been to Europe and West Africa before, so his foreign travels encountered different climates. In one of his travels to Liberia, he was determined to visit a Mount Carmel church in a remote part of the country. He traveled for the duration of the six-hour trip by elevated hammock. Upon his arrival, he expected to observe the service but was asked to preach, which he did, sharing a homily on faith.

His final destination was Asia and the Pacific theater. There were two areas of operation in the Pacific: the north, operated by Admiral Chester Nimitz

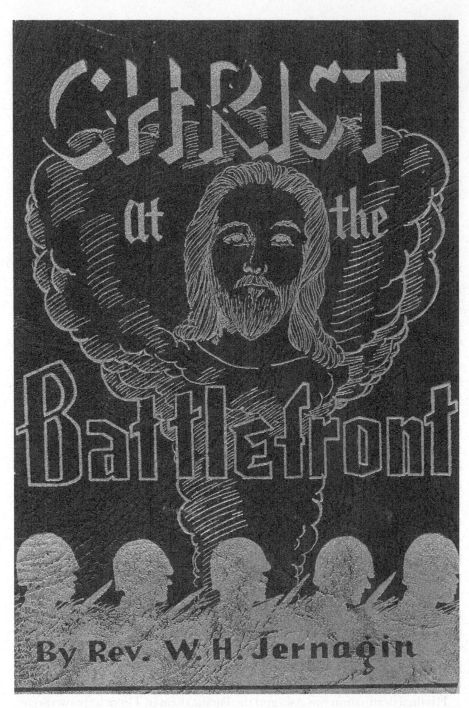

Christ at the Battlefront book cover. *MCBCA.*

and the navy, and the south, operated by General Douglas MacArthur and the army. Of the 4,300 men who served as chaplains in World War II, only 200 were African American, and Jernagin was the only senior clergy to serve. The African American clergy, like the servicemen, understood the gravity their success or failure had on the entire race. "They not only carry on the historic functions of the minister but are also personal counsellors to the soldiers and the medium through which they may make known their grievances and have them remedied."[67] Jernagin visited the South Pacific. He understood his duality in being a chaplain/social ambassador. He would preach without apology the oneness of the human family and speak out courageously against all forms of discrimination at home and abroad.

Jernagin documented his travels in a book he published, *Christ at the Battlefront: Servicemen Accept the Challenge*. The foreword was written by Robert E. Penn, a U.S. Army chaplain. Penn shared Jernagin's travels in recounting the experience:

> [Jernagin] *has a creed*—*"He believes in God and God has never let him down." This he attempted to share with the servicemen with whom he was privileged to meet and it is worthy to note that more than 2,000 accepted God and his Christ on this mission where he spoke to some 50,000 Negro troops, traveling 33,000 miles by air, 1,800 miles by auto and 200 miles by boat* [over forty-two days].
>
> *The peoples of the world are tired of half-truths, and only the truth of God as we find it reflected in the life of Christ, is complete enough for our confused world. This we must find and when we find it we must share it, that this earth of ours might become a real brotherhood.*[68]

Jernagin viewed this as a beneficial opportunity to investigate the overall conditions of servicemen, to know the contradictions and unfair treatment they endured while fighting for democracy. Unlike any other organization, Jernagin believed the church offered the only solution: the way of Christ. He sought to remind the young men that the Negro church was aware, awake and alive and that the NFCNC, collectively across denominations, sought to push for civil rights along with others in the struggle for equality. The fight was not only on the battlefields but also in the courtrooms, classrooms and halls of Congress. The NFCNC, NCNW and others were fighting to create a welcoming space for all men in the postwar period. Equity in employment, housing and education were being worked out and would be awaiting them to enjoy when they returned home. Their fight was literal and symbolic;

it was against a real enemy and ghosts in the minds of white Americans. Jernagin was confident that these servicemen would be among the first to enjoy full citizenship and civil rights if they but endured with integrity the hell of war against all enemies confronting them. Ultimately, he wanted all men to rethink life and its significance, "giving themselves real peace" only found in Christ. Jernagin believed his mission was "to help tie the broken threads of themselves together, when men are put together as individuals by the spirit of Christ the world will come out all right."

The great work in the South Pacific required Jernagin to travel to California. His cross-country journey hit a snag in San Francisco at the Palace Hotel. Jernagin was informed that Negro patrons were not accommodated there, regardless of their final destination, purpose or fellow travelers. Jernagin noted "an emissary of goodwill, commissioned by the highest authority in the country, accompanied by an officer in the Army, the symbol of our might our power and of our democracy denied quarters." Another hotel clerk offered him a room, stating it might cost her job. The second day, he encountered a refusal of service at a dining room. The president of Mills College at Berkeley came to the rescue. Jernagin, displeased, accepted the indignities as pebbles in the quarry occupied by black servicemen. He wrote, "So, armed with the faith which scorns circumstance and consequence, I knew that I must go to the Pacific to our fighting men and do what little I could to encourage them."

At his first stop in Honolulu, he was flooded with questions about life on the mainland. He answered the questions he could pertaining to his travels and assured the men that the folks back home were proud. The men provided a tour of their barracks. The condition of native Hawaiian people was not lost on the men, who informed Jernagin of the work on the pineapple plantations. One black sergeant shared a native encounter with Jernagin. The family was welcoming and pleasant, and when he entered their home to sit, a child rushed to get a pillow so that the black sergeant would not hurt his tail when he sat. Where did this idea come from? Imported white racism about African Americans. Jernagin preached a sermon that evening, and some men promised to rethink their lives. In Guam, he encountered high morale among the naval troops.

> *I think it is worthwhile to mention, that here among these Naval troops there was peculiar kind of high morale, and I was informed that they were doing especially well in their assignments. When I talked with some of the men, they expressed their interest in proving to themselves*

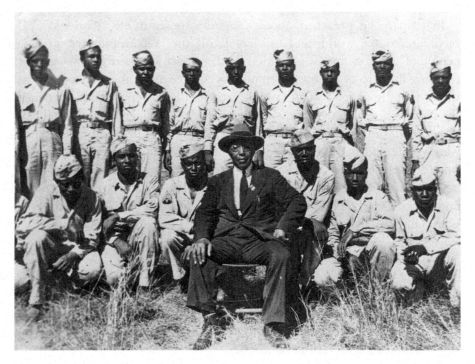

Jernagin with servicemen from Washington, D.C. *MCBCA.*

and to the world that Negroes are capable of serving in any branch of service of their country; and that they can accept their assignments as not only duty, but as a privilege an opportunity to prove the competency of fifteen million people. [69]

While in Guam, he spoke to white chaplains who supervised African American servicemen. The white chaplains felt that African American men would be better served by African American chaplains because of mutual antagonism, real or imagined. At the same time, servicemen noted that there were good and bad white and African American chaplains. The pollutant of American racism found itself in the barracks throughout the South Pacific. Jernagin found it lamentable that hate and bigotry clogged the channels of those designated to share the goodwill of the gospel of Christ. While in Guam, he addressed more than five thousand men in an open meeting. His message criticized whites for judging the entire Negro race on the behavior of one, as well as blacks who viewed whites the same way. There is good and bad in all people; the individual encounter should dictate the relationship. After the service, there were seven hundred men who accepted the invitation of faith.

In Saipan, he preached about imagining postwar life. World War II reconfigured the world, and "society [had] the responsibility of arming people of all races and of all nations with respect for other peoples and of teaching them to overcome differences by appreciation and understanding, rather than by oppression and resentment." The ugly encounters hardened the resolve of some men against any hope of interracial cooperation. Their resentment, justified by unrelenting attacks, bothered Jernagin. These men were young and had their entire lives and future families to consider. The small island confined the men with no physical separation, augmenting latent distrust. There were two letters from soldiers that encouraged him and applauded the NFCNC. Napoleon Marks from High Point, North Carolina, was so inspired by Jernagin's sermon that he penned a poem in tribute:

> *I remember the words of* [Jernagin]
> *And in my heart they will stay*
> *For a man that has lived as long as he has*
> *Only God has provided a way.*
>
> *This moment has come for me to think*
> *The way my soul has been lost*
> *So open thy heart, and live again,*
> *For Jesus is our only boss.*
>
> *We have lived in sin for many years,*
> *And yet Jesus has spared our heart,*
> *So stop and rethink of the past that has gone*
> *And let Jesus play our part.*
>
> *There is one that believes in us,*
> *No matter what kind of life we live,*
> *So stop today, and think of tomorrow*
> *Until the word of God is fulfilled.*
>
> *This world should be combined as one*
> *Regardless to color or creed*
> *No man on earth can rule the world,*
> *When God has provided his need.*

He gave me life as He gave you,
In the soul of every man
Not one of a million can fool his heart
For God always understands

So rethink your life over now,
Just as I will do,
And when He calls be ready to go
And the doors will be open to you.[70]

Jernagin concluded his travels efficiently and immediately provided a report for President Truman, the military and the black press. In his letter to Truman, he commended the government on its sincerity by sending a Negro representative on a goodwill mission. That opportunity provided fertile ground for additional improvements in race relations. He asserted that "America must demonstrate the democratic principles which she advocates by affording the Negro people every privilege and right as citizens of America; by recognizing and appreciating the extreme sacrifices and contributions made to this nation and the world by our Negro fighting men."[71] By proxy of the letter, Jernagin preached to President Truman the same words: rethink life and accept the challenge of Christ.

Chapter 5
The Champion Passes On

J ernagin entered his final decade of life enthusiastic about the potential for the faith in Christ growing among young people and the fight for justice being secured through the Washington Bureau and other organizations.

THE THIRD ONE IS A CHARM

Jernagin was awarded three honorary degrees. All three were doctorates of divinity: Guadalupe College, Seguin, Texas, 1908; Simmons College, Louisville, Kentucky, 1949; and Howard University, Washington, D.C., 1951. These institutions were all founded by Christian organizations. Jernagin was a lifelong learner and founded two Baptist seminaries. His work with the NBC and its National Sunday School and Baptist Young Peoples Union (BYPU) was acknowledged, as well as his dedication to biblical instruction.

Guadalupe College was founded in 1884 by Dr. W.B. Ball. It was located on a beautiful spot in the central part of Seguin, Texas. According to the notes of Guadalupe College history, "The location was claimed by all to be the very best site and the most attractive property in the city." The campus covered five acres and formerly served as a school for white women training for missionary work. The early years were frustrated by the American Baptist Home Mission Society, which opposed the formation of Guadalupe College. The wrangling pushed back the admission of students until 1887.

The student body was composed of young men and women from various southern states. The scheme impacted the Baptists of Texas, resulting in a split among the black Baptists. One group advocated self-help, denominational enterprise and race pride, while the opposition favored racial dependence and intellectual subjugation. During the fight to destroy Guadalupe College, it continued to grow and blossom like a rose for a number of years. The courses offered were theology, music, millinery and dressmaking. Guadalupe College history continues to record that "the students are invariably making good in their chosen professions, and many of them standing at the top of the ladder."[72]

An essay titled "The Open Door" in the Guadalupe College history notes details the explicit importance of Christian education:

> *Man's intellectual progress depends upon the accuracy with which he can solve the problem of life. His happiness depends upon the willingness and fidelity with which he conforms his conduct to righteousness and justice. Nature is heartless but impartial; merciless but kind; easily entreated but unalterably purposeful.*
>
> *Life's goal is peace, and nature's condition is justice…The goal sought by the founders of this country has not been reached because the seekers persist in taking the wrong road. Class distinction, religious restriction, race-discrimination are the blind alleys our nation has mistaken for the open road of progress. Democracy is every man's obligation and every man's opportunity it must find its expression in character and conduct and not in color and condition. Merit and not race is the measure of men.*
>
> *In a country like ours there are but two places where civic status comes to strict equilibrium full citizenship with every right conceded or abject slavery with every right denied. The black man in America spent ten generations in the latter condition when a civic cataclysm broke his chains and headed him toward the goal of full citizenship…Character and not race is the just standard for measuring men. A man is responsible for his conduct, not for his color. One should be neither praised nor blamed for what he can neither cause or cure…What we need here in America is more racial self-respect and less racial antagonism. That and that alone is the solution of the vexatious problem that has and is worrying the nation.*[73]

The mission of Guadalupe College was resonant throughout the ministerial career of Jernagin. By 1908, he had founded his first seminary and was living in Oklahoma. His advocacy for civil rights was consistent

and well documented in the *Safeguard*. Guadalupe College felt that Jernagin's example was a fitting model for its faculty and students. The honorary degree that he received reads: "This certifies that Reverend W.H. Jernagin is approved of Christian Character and has given satisfactory evidence of Theological training and marked ability as a teacher of righteousness and is admitted to the degree of Doctor of Divinity signed November 28, 1908." Unfortunately, as a result of fiscal instability, Guadalupe College closed by the 1930s.

Jernagin received a second honorary doctorate from Simmons College of Kentucky in 1949. Simmons was founded in 1879 by formerly enslaved people to teach their children. In August 1865, Baptist minister Reverend Henry Adams crusaded for the creation of a school in Kentucky at the State Convention of Colored Baptist Churches meeting at Louisville. The idea was bandied about the Baptist circles until November 1879, when the Kentucky convention trustees purchased several acres of land in Louisville to serve as the main campus. The initial school name was Kentucky Normal Theological Institute. In 1880, the second president, Dr. William J. Simmons, expanded the institution. Simmons, trained in education, augmented the instructional offerings in liberal arts. He also added law, theology, medicine and business courses. In 1884, the school was recognized as a state university. Simmons also implemented athletics, creating intramural sports teams. As the university grew, additional courses were offered in partnership with the University of Louisville in nursing and law. In 1918, in acknowledgment of his decades-long contributions to the school, it was renamed Simmons University. Simmons died in 1890. Although the school was thriving and attracting students, the Great Depression greatly impacted all aspects of the university. The school lost land, students and financial stability. These hardships reduced the school to a "colored branch" of the University of Louisville. Jernagin's honorary doctorate reflected the school's lingering theology program. Unlike Guadalupe College, Simmons rebounded and is a fully functioning place of higher education. The college's motto, *Palma Non Sine Pulvere*—literally meaning "no palms without dust"—refers to the prize of palms or a wreath awarded to the winners of chariot races and bespeaks the tenacity Baptists in general and African Americans in particular have overcome to pursue and provide education.

The third honorary doctorate of divinity came from Howard University. Unlike Guadalupe and Simmons, Howard University was organized by the Congregational Church. Initially intended to be a school of theology in 1866, Howard University was chartered as a liberal arts university by an act of the

Jernagin (left), President Mordecai Johnson (next to him) and others during the awarding of Jernagin's honorary doctorate of divinity, 1951. *MCBCA.*

United States Congress in 1867. During its infancy, Howard attracted all types of students, including the white children of many of its earliest instructors. By the 1890s and well into the 1950s, Howard was labeled "the capstone of Negro education" because of its central role in the production of creative, innovative and path-finding African American minds. Named after Oliver Otis Howard, a white Civil War general and commissioner of the Freedmen's Bureau, Howard welcomed any student willing to learn. The first black president of Howard was Baptist minister Mordecai W. Johnson. The rumblings from students and faculty about the course of direction led to a demand for black administrators whose reality and race would charter practical solutions for the race and shrug off the paternalism of white administrators.

During his tenure, Johnson expanded the academic offerings, including a doctoral program in arts and sciences in 1958. The Johnson years (1926–64), dubbed the golden years, witnessed an explosive production in scholarship, public policy and activism for black people in America and abroad. On faculty were notables such as Alain Locke, the first black Rhodes scholar;

Jernagin being congratulated by President Mordecai Johnson, 1951. *MCBCA.*

Kelly Miller, mathematician and sociologist; Ralph Bunche, political scientist and later Nobel Peace Prize winner for brokering peace between Israel and its Arab neighbors; Merze Tate, historian and Fulbright scholar; Lois Mailou Jones, visual artist; and Charles Hamilton Houston, law professor and intellectual architect of the *Brown v. Board of Education* legal argument. The *Brown* decision utilized all fields of scholarship resident in the university, from historians to sociologists to psychologists. Johnson's leadership style antagonized faculty, students and alumni; however, he remained firm, and his legacy is unrivaled.

For Jernagin, being acknowledged by Howard made the third honorary degree a charm. He was notified by Howard vice-president James Nabrit. Nabrit would become Howard's second black president and its first alumnus to hold the office. He was a product and copilot of the Johnson legacy. He attended law school under the tutelage of Charles Houston and later worked for the university as an instructor and administrator from 1936 to 1960. It is believed he orchestrated the first class on civil rights at the law school in 1938. His career included time in the United Nations and a presidential

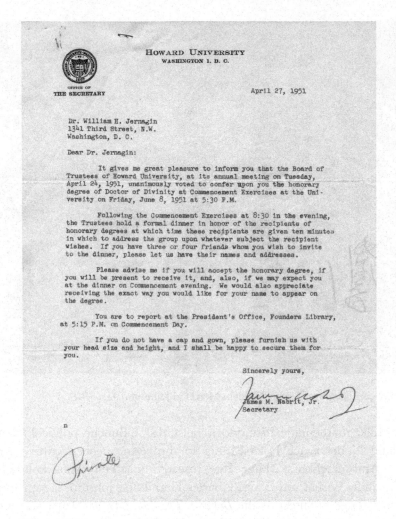

The letter from James Nabrit to Jernagin informing him about being awarded an honorary degree. *MCBCA.*

appointment. Jernagin knew Nabrit's father, who was a Baptist minister in Atlanta. In response to Nabrit's letter, Jernagin replied, "It is a great and pleasant surprise to be informed that the Board of Trustees of Howard had agreed unanimously, it is a pleasure to accept this degree from the greatest institution we have in our racial group, I certainly want to express my appreciation to the Board of Trustees and everyone who had anything to do with bringing this about."[74]

In the remarks read during the conferring of the degree, Jernagin's accomplishments were chronicled, from Mashulaville to Mount Carmel:

Dr. W.H. Jernagin, Gospel minster, civic leader, educator, and world traveler. Under his pastorate, Mt. Carmel was the first Negro church in the District of Columbia to employ a paid social worker. He was the first to advance the idea of the Junior Church, (1923), and the integration of the youth in the regular church service. The latter he put into practice in Mt. Carmel in 1934...Through his appearance before the Senate and House Committee representing the NFCNC, many cases of discrimination have been brought to light...It is said of [Jernagin] that he has done more to unite the Baptist forces in [Washington] than any other man. Under his leadership the first Baptist Convention in the District of Columbia was organized.[75]

The citation continued to provide a succinct reason for his being awarded an honorary doctorate in 1951. President Mordecai Johnson remarked:

William Henry Jernagin, your life of 82 years all but covers the entire span of American history since the emancipation of the slaves; and there is no man alive who knows better than you do, in your own body, heart and mind, what it has meant to the children of slaves to be required to build up their lives under the economic, political and educational difficulties before them in the former slave states and in the presence of segregation, social humiliation and spiritual condescension which have prevailed there. There is no wonder that early in your life in Mississippi you sought for freedom from such a world in religious devotion to the God and Father of Jesus of Nazareth.

The wonder of your life is this: That your religious devotion, instead of making you a seeker after mere personal satisfaction in a life of short-radius deeds performed within the accepted bounds of segregated public order, has operated to galvanize you with social passion and to transform you into one of the most energetic and fertile workers for human betterment to be found in the ranks of the clergy in America...

You have been a vigorous contributor to the growth of cooperative work among local churches, among the denominations, and among different religions; and wherever you have touched these religious organizations, you have sought to bring their moral power creatively to bear in the advancement of freedom and justice and brotherhood in this literal world.

In your own city of Washington there is hardly an organization engaged in human welfare and betterment which has not known your presence, encouragement and support.

It has been a good and beautiful thing to see what energy of love and what radiance of constructive activity God has been able to bring out of your humble life.

William Henry Jernagin, by virtue of the unanimous vote of the University Council representing all of the faculties of the University, and by unanimous vote of the Board of Trustees, I do confer upon you the Honorary Degree of Doctor of Divinity.[76]

REVEREND ERNEST ESTELL, BROTHER AND FRIEND

The fatherhood of God makes all Christians brothers and sisters. Those in ministry often use the term "brother" to reinforce that biblical foundation. Through the archives at Mount Carmel, the pictures of Jernagin and Ernest Estell are numerous. Often two men are pictured at pulpits together, in meetings or seated in dialogue. In viewing the images and learning about the aggressive and popular ministry of Estell, it is no surprise that he is in Jernagin's company. They charted a course for the civil rights movement in the NBC's National Sunday School department. They integrated their preaching and quest for social justice into lessons for their members of all ages. Jernagin predeceased Estell; however, the bonds of friendship remained.

Ernest Cobell Estell Sr. was born in Decherd, Tennessee, on January 12, 1897. His early education included LaMoyne College in Chicago and Simmons Theological Institute in Nashville. As a young man, he worked in a coal mine and preached part time. His first pastorate was Bethel Baptist Church in Drakesboro, Kentucky. In 1931, he went to Tabernacle Baptist Church. During his tenure of six years, he married Lee Ella Payne. In 1934, he attended the World Baptist Alliance meeting in Berlin, Germany.

He was a passionate minister and ardent Baptist. Throughout his various pastorates, he grew in the denomination and was involved in the local community. A junior contemporary of Jernagin, Estell appreciated the tenacious endeavors of the NBC. Its push for soul salvation, educated ministers and well-versed members impelled Estell to be a lifelong student of scripture. His rising popularity in the NBC attracted the attention of notable preachers who he invited to his pulpit at Tabernacle Baptist. During his tenure in 1935, Tabernacle Baptist welcomed the NBC National Sunday School and Baptist Training Union Congress meeting. It is possible that Jernagin and Estell crossed paths during those years when Estell was in Ohio.

Jernagin (seated, center), Ernest Estell (to his right) and others, with Mordecai Johnson speaking at a church anniversary. *MCBCA.*

Estell, Jernagin and an unidentified man in Omaha, Nebraska, undated. *MCBCA.*

Estell, Walter White and Ralph Bunche, undated. *MCBCA*.

In December 1937, Estell and family moved to Dallas. He was installed as the pastor of St. John Baptist Church. While at St. John Baptist, his ministry exploded. He orchestrated the construction of a new church building that cost $1 million. This was remarkable on the cusp of World War II. His dynamic preaching and new building grew the membership to over 4,000 parishioners. His leadership and church growth positioned St. John Baptist to become the largest black Baptist church in the Southwest. It has been recorded that between 1,000 and 2,500 people attended Sunday services.

Estell involved himself in local, regional and national organizations. He served as the local founder and president of the Interdenominational Ministers Alliance in Dallas. He joined the call for interorganizational unity among churches and black groups. The internal struggles with denominational schisms, intra-racial matters and lingering class struggles detracted from the larger goal of a just and democratic society. One parishioner recalled him stating from the St. John pulpit, "It is one step from where I am to where you have to go." The underlying meaning of this statement is that there is efficiency and strength in unity.

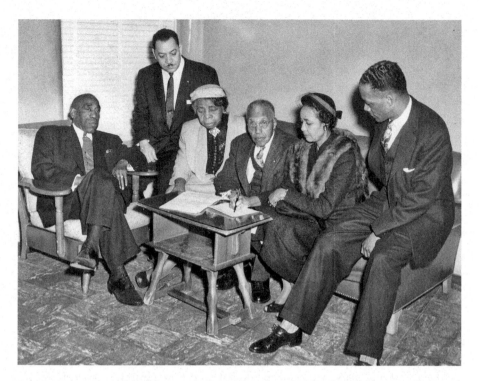

Estell, Lucy Campbell, Jernagin, Bessie Estell and Fisher. Dr. Paul Casey is standing. *MCBCA.*

Estell worked for the civil rights movement in Dallas through the NBC, NAACP and the interracial Dallas Committee of Fourteen. The conditions of Texas in general and Dallas in particular required a gradual and consistent pressure, which Estell masterfully exerted throughout his life. He and Jernagin held membership and offices in the board of directors of Baptist World Alliance, Knights of Pythias, Order of the Eastern Star, NBC National Sunday School and Baptist Training Union Congress and the NBC. Estell received honorary doctorates of divinity and law. Both received honorary doctorates from Simmons College in Kentucky. Similar in their paternity, both had four daughters, although Estell had an additional five sons.

Estell recounted the funeral of Jernagin for a variety of Baptist publications. He noted that the service lasted three hours and fifteen minutes and that men from every walk of life and across the nation journeyed to pay a tribute of respect "to one of the most unique characters to ever stroll down the corridors of history":

College presidents were there, dignitaries across the race line, on which he achieved some of his most notable victories, were there...thousands of the humble who will never make a headline were there...the church was crowded, the streets were crowded, and after some thirty speakers had spoken...all that remained mortal of William Henry Jernagin was carried to those quiet and beautiful slopes beyond Anacostia, toward which we all are marching with a steady tread. To a friend, we said, GOOD NIGHT.[77]

SONS IN MINISTRY, YOUTH ENCOURAGED

The same principle of God's fatherhood applied to the youth. The young people were collectively children, and as they aged, they became sons and daughters. Jernagin was actively committed to the youth. His presidency of the Baptist Young People's Union was not simply a title but also a ministry to educate, model and encourage the youth in the Christian faith and Baptist tradition. Thomas E. Bergler, in his recent work *The Juvenilization of American Christianity*, argues that most Protestant churches actively focus on the youth in their denominations with the intention to retain members and inculcate specific spiritual values. "Juvenilization is the process by which the religious beliefs, practices and developmental characteristics of adolescents become accepted as appropriate for Christians of all ages."[78] The adaptation of the faith to appeal to the young is well intentioned but a possible detriment when the faith is reduced to immature actions. The 1930s and '40s witnessed a blossoming of youth ministries and beneficial reforms to keep young people interested. Music, socialization and personal involvement altered the direction of the church, which could have contributed to the civil rights activism of Martin Luther King Jr., Gardner C. Taylor, Rossie (R.L.) Patterson, Andrew Fowler, Carey E. Pointer Sr. and other young men Jernagin engaged with while president of the NBC National Sunday School and BTU. Bergler notes that the secular culture witnessed the birth of the "teenager," whose culture heavily influenced popular culture from movies to television to music. All teenagers were not consciously aware or participatory, but the adults of the era were aware that technology altered experiences, forcing them to reconsider what being an adolescent meant.

Jernagin wrote in 1945 that young people returning from war, similar to those after World War I, would not tolerate or endure old injustices. America

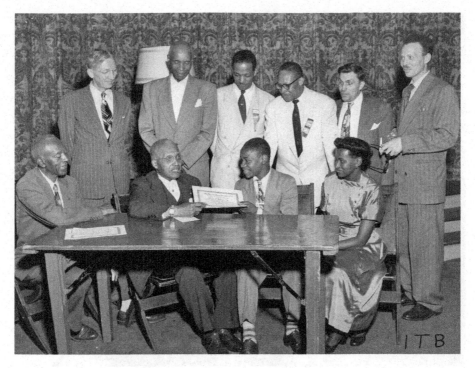

Jernagin presenting the American Youth Award in 1955. *MCBCA.*

and the church needed to work toward implementing a program that would equitize social, economic and political arenas. To offset any volatile episodes, the black church invested in creating youth programs including Boy Scout troops, vacation Bible schools and oratorical contests. According to Bergler, "These innovations strengthened the churches and convinced both adults and young people that youth really were politically powerful." Bergler commended Jernagin's programming, which attracted adults, youth and children. Jernagin's Baptist Training Union (BTU) Congress instructed attendees and trained them how to run youth programs. The sessions were usually followed by a social activity. The NBC implemented Youth Sunday, where children and youth were allowed to conduct the service. These exercises afforded the youth a voice and witness of how spiritual life was lived out and the responsibilities intrinsic to leadership.

In 1953 [Jernagin] *modeled civil rights activism by personally integrating movie theaters and restaurants in Washington. For their part, teenagers who grew up in Baptist circles in the 1950s knew the power of a public*

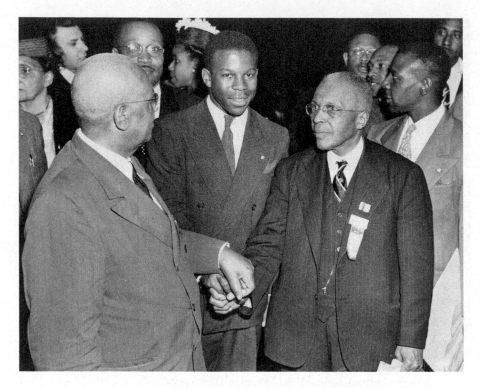

Jernagin greeting an unidentified man with a youth. *MCBCA.*

> *march to build solidarity and dignity well before the civil rights leaders used that technique. Such militancy was all the more striking given that the main work of the* [BTU] *was to train National Sunday School teachers, youth leaders…Growing up in the black Baptist church taught* [young people] *to see life as a battle between good and evil, to value total life commitment…The emotions and moral convictions they found in the civil rights movement would therefore reassure them that their cause had divine approval and ultimate significance. The religious experiences of childhood prepared* [them] *to act courageously and to understand their political experiences as redemptive. Those same political experiences then became a lens by which to reinterpret their Christianity.*[79]

This fusion of justice and faith was a strong element of Jernagin's National Sunday School presidency. His commitment to this ideal was transfused to those young men he mentored and encountered in ministry. There were many men and women influenced by Jernagin. The following five were directly impacted, and their ministerial careers mirrored Jernagin's in honor and duty.

Rossie Leonard (R.L.) Patterson was born in Alabama in 1919. He attended Alabama State Teachers College in Montgomery and Howard University's School of Religion. His service to Jernagin started in the 1940s. Patterson served in the army during World War II. It is unclear if he encountered Jernagin during his military service, but it is clear that he joined Mount Carmel and remained a committed minister, resulting in being named senior pastor in 1959, a year after Jernagin's death. He was director of Christian education at Mount Carmel from 1951 to 1955.

He picketed with Jernagin and Mary Church Terrell against segregation. The diminutive man with boyish looks was often mistaken for being younger, but he did not let this deter his crusade for justice. During his tenure as senior pastor, a new church was constructed. The congregation entered its new sanctuary on Sunday, October 19, 1980. On November 2, 1986, the mortgage was burned, leaving the property debt free. Patterson, the seventh pastor to serve Mount Carmel, is second in terms of service, with twenty-seven years to Jernagin's forty-six. He was active in the NBC, served as dean

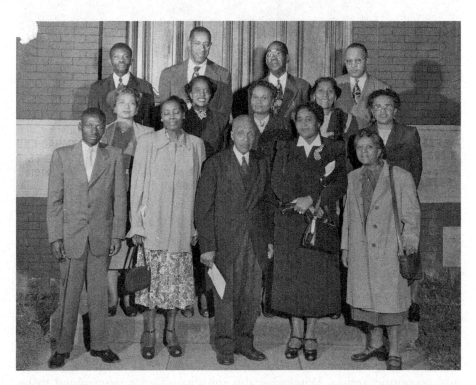

Jernagin (front row, center), Patterson (front row, first man on the left) and assistants to the Mount Carmel pastor. *MCBCA.*

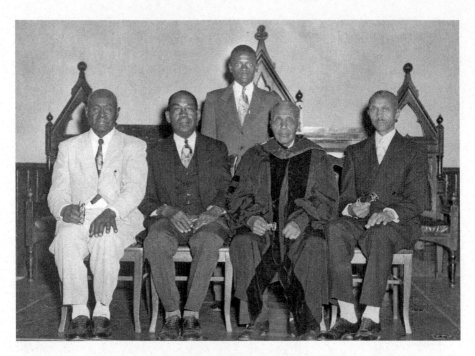

Jernagin (seated, third from left), Patterson (standing, center) and the Mount Carmel Religious Education Committee. *MCBCA.*

of the PNBC, was president and dean of the Baptist Educational Congress of Washington, was on the executive board of the Baptist Convention of Washington and was dean of the PNBC's Congress of Christian Education. He was appointed to the D.C. Health Commission by Mayor Walter Washington. For the next four years, he was pastor of the First Institutional Baptist Church in Winston-Salem, North Carolina. In 1959, he returned to Washington and succeeded the late Reverend Dr. William H. Jernagin as pastor of Mount Carmel. A full portrait of Patterson is being developed by the Mount Carmel archives committee through his personal papers, which are under negotiation with his family.

Gardner C. Taylor was born on June 18, 1918, in Baton Rouge, Louisiana. His parents were Reverend Washington M. and Selina Taylor. His father was a Baptist minister and the son of slaves. By age thirteen, Gardner's father had died, and he was raised by his mother and an aunt.

His early education was in segregated schools. The larger city of Baton Rouge drew a thick line between white and black in all social, political and economic arenas. Witnessing this injustice, Taylor determined to be a civil rights lawyer, although no black person had ever been admitted to

the Louisiana bar. In 1940, he enrolled in Oberlin College and pursued a degree in divinity. While at Oberlin, he became the pastor of Bethany Baptist Church. In 1941, he served in his late father's pulpit at Mount Zion Baptist Church.

In 1948, at the age of twenty-nine, he went to Concord Baptist Church in Brooklyn, New York. Concord had a rich history of activism and a large congregation. Taylor accepted the appointment and remained its pastor for over forty years. During his tenure, the church rebuilt after a fire, raising $1.7 million in 1955. This successful campaign coupled with powerful preaching witnessed a surge in members. The church established a credit union to provide loans that commercial banks denied blacks. It also opened a 121-bed nursing home for the sick, a community center for the elderly and an elementary school for the youth.

On November 18, 1949, Taylor wrote to Jernagin on his eightieth birthday:

> *Let me add my and Concord's felicitations to you and this significant milestone of America's most colorful ministry.*
>
> *You have been an inspiration to all of us, we look to you as Elder Statesman. Your contributions to world Christianity are monumental. Seer of the race, leader in the ranks of humanitarianism, pivot character in Negro Baptist relations to the world church, rarely gifted preacher of the Gospel of Christ, friend to us all, we salute you with the hope that we shall have you among us for many years to come.*[80]

Taylor gained national prominence in 1961 when he joined with other black clergy members to found the Progressive National Baptist Convention. The PNBC, along with his ministry, was committed to social justice, desegregation and civil rights. Taylor served as PNBC president from 1967 to 1969.

The PNBC provided Dr. King and others with a national network of churches for the civil rights struggle. Locally, Taylor organized protest marches. Taylor's *New York Times* obituary notes his impact as a speaker, writer and political force in the city. In a nation of long-segregated schools, churches and other institutions, he reached far beyond his ten-thousand-member congregation.

On the occasion of his ninetieth birthday, Taylor offered "Reflections":

> *One of the great contributions of the black church was giving to our people a sense of significance and importance at a time when society, by design, did almost everything it could to strip us of our humanity. But come Sunday*

morning, we could put on our dress clothes and become deacons, deaconesses and ushers, and hear the preacher say, "You are a child of God"—at a time when white society, by statute, custom and conversation, just called us "niggers."

How could we have survived without a sense of God and the church telling us that we do matter? Where would we have been if there had been nowhere we could be told that we matter?[81]

Andrew Fowler was born on February 23, 1910, in Inman, South Carolina. His parents, John Calvin Fowler and Ina Nesbitt, provided a loving home. Fowler's life was grounded in faith and hard work. The ugliness of racism reared its head throughout his lifetime, but his Christian response was love, faith and action. His membership in Zion Hill Baptist Church provided him a forum to exercise his innate leadership skills. His childhood pastor, Reverend W.M. Lipscomb, baptized him and prophesied greatness in and throughout his life. Fowler served the church faithfully in National Sunday School as a teacher and then assistant superintendent. He also served on the local BYPU as president. On the occasion of his eighteenth year of life, he was ordained a deacon. He received his education at Tuskegee and Howard University. Fowler was a humble man whose encounters with notables like Tuskegee president Dr. Robert Russa Moton, Dr. Benjamin Mays and others impelled him to apply himself on behalf of Christ and the race.

His initial encounter with Jernagin came via the Washington Seminary. Fowler started teaching at the seminary in 1947, and his relationship grew until he held the office of president and would continue until his death in 2003. Through the Washington Bureau and the seminary, Fowler remained committed to social justice. Historian John Fowler noted that "Jernagin's vision made a deep impression upon the young pastor's concern for cooperative religious work."[82] His proximity to Jernagin allowed for mentoring and modeling unparalleled in locally recorded history. Local matters were Fowler's greatest concern. Fair housing, employment and healthcare were dire needs of Washington's poorest people. The city was still under the jurisdiction of a board of commissioners and did not have the federal visibility of a state or an advocate in Congress or the Senate. Fowler's legacy and Jernagin's influence are resident at Capital View Baptist Church, where two Fowler generations continue to link belief in Christ, educational instruction and social justice together in hope of making a life equitable for all residents.

In an interview in June 2015, Reverend Dr. Carey E. Pointer Sr. offered personal reflections on Jernagin. Dr. Pointer, pastor emeritus of

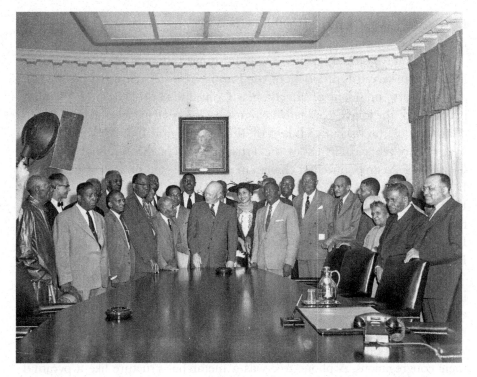

President Dwight D. Eisenhower (center), Jernagin (front row, fifth from left), Andrew
Fowler (behind Eisenhower to the left) and Fraternal Council of Negro Churches members.
MCBCA, photograph by Clifton Cabell.

Providence St. John Baptist Church, Upper Marlboro, Maryland, recalled
being invited to live with the Jernagins when he arrived from Houston,
Texas, in Washington during the 1950s. As a young man, he found
himself restricted by the "rules" of the Jernagin household. His father,
a prominent preacher in Houston, had guided his son into ministry; this
urging did not manifest easily. Being a preacher's son, Pointer recalled the
ugliness of some church members, but an encounter with the Holy Spirit
confirmed his father's guiding. Initially, Pointer came to Washington
to join the U.S. Air Force. En route to Washington, he had another
encounter with the Holy Spirit confirming a call to ministry, but Pointer
refused to listen. Within six days after his arrival in Washington in 1951,
he joined Mount Carmel. He joined the senior choir, attended prayer
meeting, headed the youth department and intermediate department of
the BTU and was a Scout master, but he was unfulfilled. One Sunday
morning during the hymn of preparation, the choir sang "Where He

Leads Me I Will Follow." The following morning, Pointer acknowledged his call and sought Jernagin's advice.

Dr. Pointer pastored for fifty-two continuous years before his retirement in 2007. He served as president of the Baptist Ministers Conference of D.C. and Vicinity; president of the Baptist Convention of D.C. and Vicinity; president of the John F. Kennedy League for Universal Justice and Good Will; chairman of the Executive Board of the Washington Baptist Seminary for over twenty years; chairman of the Trustee Board of the National Fraternal Council of Negro Churches; chairman of the Trustee Board of the Walter H. Brooks Student Center; director of the World Baptist Training Center, D.C. Area; board member of the Stoddard Baptist Nursing Home for over thirty years; state vice-president of the National Baptist Convention, USA, Inc., for eight years; and member of the Home Mission Board, National Baptist Convention, USA, Inc.

In recounting the effectiveness of Jernagin as a national leader, Pointer indicated that Jernagin was skillful in utilizing the technology and methods of communication during his era. The phone tree was a popular tool in the hands of Jernagin. When issues were going before Congress for a vote, Jernagin would use his phone tree to galvanize pastors across the country to inform their congregations. A phone tree was a hierarchal structure like a pyramid by which information was systematically diffused country-wide, resulting in a cumulative impact. This minor aspect proved invaluable in the modern civil rights movement, along with poster making and old-fashioned word of mouth. Keeping the community informed and empowered was essential to the success of the civil rights movement and the tenacity of Jernagin's strength and popularity. Pointer marveled at that fact and remains current, informed and alert to developments within the NBC locally, regionally and nationally.

Jernagin was slow to offer Pointer the opportunity to preach. His first opportunity was scheduled for December 7, 1952, and Pointer preached his trial sermon. While at Mount Carmel, he met his future wife, and they were married for fifty-eight years. His first preaching engagement was a home church of three members, earning him a three-dollar offering. His reminiscence of Jernagin presents a stern, witty man concerned with the well-being of his congregation and young minsters. Pointer continues the mentoring tradition of Jernagin, providing godly insight to optimize young people's ministerial careers. Moreover, Jernagin encouraged and chided Pointer during his formative pastoral years. In the less than ten years they were affiliated, Jernagin's sage wisdom provided Pointer with a consistent and temperate approach to ministerial and life decisions.

Dr. Pointer received a BA degree from the Inter-Baptist Theological Center in Houston, Texas, in 1967 and was honored with a doctor of divinity degree by the same school. He is a longtime member of the American Institute of Parliamentarians (AIP). Currently, Dr. Pointer serves as the historian of the Virginia Scholtzhaur Chapter of the AIP of Washington, D.C. Over the course of his ministerial career, Pointer has licensed twenty-three men and women in ministry. He taught church history at the Washington Baptist Seminary from 1982 to 1985. His favorite scripture is Romans 5:8: "But God commended his love toward us, in that, while we were yet sinners, Christ died for us."

Billy Graham, though not directly influenced by Jernagin, encountered him when he preached a revival in Washington. Graham's preaching style attracted huge crowds, both black and white. However, the de jure segregation in Washington would not allow integrated audiences.

When he and Jernagin were awarded clergyman of the year and gifted honorary life membership certificates by the Washington Pilgrimage (a religious and cultural heritage society) in 1957, no one could have projected the fabulous ministry career of Graham. During the course of his active ministry, he preached to approximately 215 million people in live audiences across 185 countries. Jernagin and Graham came to the Baptist faith from different perspectives; however, their belief in Christ allowed them to share one moment in history. Jernagin did not allow their encounter to pass without challenging the young evangelist to strike down segregation as ungodly.

This rebuke came in the wake of a revival meeting Graham conducted in Washington that adopted the segregationist policy of Washington. His good looks, charisma and post–World War II appeal were needed to join the long fight for civil rights. Graham spoke out against atheistic Communism. He paralleled its belief to that of Christianity, stating, "Either communism must die, or Christianity must die, because it is actually a battle between Christ and anti-Christ." With the rise in nuclear weapons during the Cold War, Americans sought solace in a spirituality that had a good-bad dynamic, sans segregation and racism. Graham remained aware but largely silent on the issue of civil rights.

William Franklin Graham Jr. was born on November 7, 1918, in Charlotte, North Carolina, to parents William and Morrow Graham. He was the first of four children raised on a dairy farm. His parents were strict Calvinists. At the age of sixteen, Graham attended a series of revival meetings run by evangelist Mordecai Ham. Ham's sermons on sin appealed to Graham.

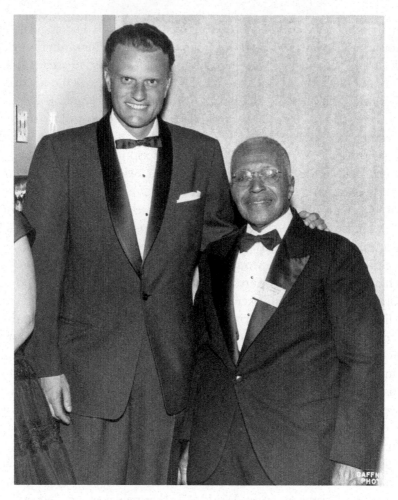

Billy Graham and Jernagin at a 1950s award ceremony. *MCBCA,*
photograph by Gaffney photographers.

After high school, Graham moved to Tennessee to enroll in the Christian
school Bob Jones College. Finding its rules rigid, he transferred to Florida
Bible Institute. In Florida, he encountered the Southern Baptist Convention
Church. He joined and was ordained in 1939. After graduating, he went
to Wheaton College in Illinois for additional studies. He pastored the First
Baptist Church in Western Springs, Illinois. In 1949, when he was invited
to preach a revival in California for a group called Christ for Greater Los
Angeles, his charismatic style during a radio interview with Stuart Hamblen
promoted the revival and launched his career as an evangelist.

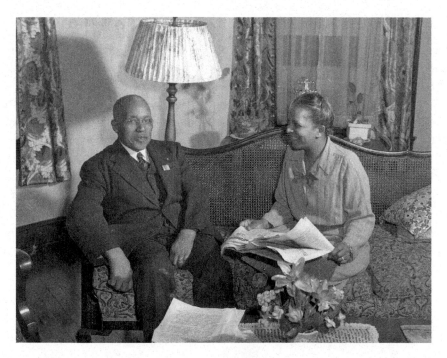

Jernagin and Cordelia Jernagin at home. *MCBCA.*

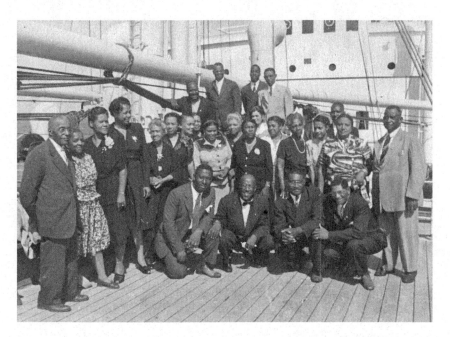

Jernagin, Cordelia Jernagin (far left) and others aboard a cruise ship, 1947. *MCBCA.*

THE CHAMPION FOR PEACE PASSES AWAY

Jernagin had experienced a number of losses by 1945. His two daughters and wife of fifty years all predeceased him after health challenges. He was able to find love again in the person of Cordelia Woolfolk. She was born in Frankfort, Kentucky, in 1895. She moved to Washington and started working as a claims adjuster at the National Benefit Insurance Company. National was a black-owned business. In 1939, she was listed as an employee of the Southeast Settlement House. The Settlement House was founded in 1929 by Dr. Dorothy Ferebee and offered daycare and recreation for black children. By 1945, Cordelia Woolfolk had become a social worker and wife of Jernagin. Their years together were a whirlwind of activity and travel. She was not simply a travel companion; she was also actively involved in the Women's Department of the NBC.

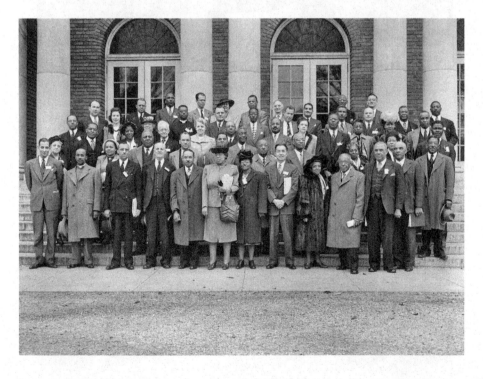

Jernagin (front row, second from right), Cordelia Jernagin (front row, third from right), Dorothy Height (fourth row, lady with feathered hat) and a ministerial delegation. *MCBCA.*

FINAL YEAR OF ADDRESSES, HOPE FOR THE FUTURE

On March 1, 1957, Jernagin issued a release to the Baptist constituency of the NBC as it was working to elect a new president. In a retrospective nature, he charged the NBC to consider the future. The times were ripe for change; he knew it because his entire life he had labored for that day when justice would be more than a demand or paper tiger but a fully actualized reality for black Americans. This moment could be lost if internal strife blinded people seeking positions in the NBC. Egos and agendas clashed openly and privately for years between wavering factions of men seeking positions. This green-eyed devil was not new for the NBC and would be a consistent reminder that prayer, grace and humility were needed to guide the hearts and minds of the membership.

Jernagin was the son of slaves who picked apples and organized sharecroppers. He knew Oklahoma fifty years before it became a state and observed how state's rights circumvented federal law. He traveled to Europe, Africa and Asia and witnessed firsthand the effects of racism, segregation and poverty. He also knew that the love of Christ and the gospel message kept him from becoming consumed with hatred and brimming with revenge. The times were ripe for change, and the NBC needed to be ahead of the change, as young men like Martin Luther King, Gardner Taylor and L. Venchael Booth were overtly challenging in the South and pockets of the North. Jernagin wrote:

> *I am probably the oldest active living member of the convention and I believe I am urged by the Holy Spirit to offer some advice with love to all and with no ill will toward anyone.*
>
> *I joined the [NBC] in September 1899, and have been a loyal, active member ever since, having missed only one session, when I was on the high sea in 1921. I have supported every board in our convention, and cooperated with every president selected by the convention.*
>
> *As Baptists, we face the greatest crisis in our history; and because of that fact, the greatest need of the entire denomination is <u>Peace</u> and real cooperation generated by a man chosen of God to lead us...Some men have the idea that they cannot be useful unless they are in the leadership of an organization, but that is not true.*
>
> *Just the other day, with all the differences which seem to exist between the former President and the present President, Mr. Eisenhower found a place for former President Truman where he could make a contribution toward the peace of the world and asked him to serve. If this is being*

demonstrated in the political world, it should be shown to a much greater extent for the peace, harmony and welfare of our denomination.[83]

Jernagin alluded to the need to consider nontraditional leaders—those who were younger, those with ideas that engaged social justice and those who were not opportunistic in being titled but not appointed for this unique time in history:

Therefore, as believers in Christ, we must always keep in mind that the cause is greater than any one of us. I think one of the great objects for which we should pray at this moment and especially on the National Day of Prayer, is that the Holy Spirit will direct the minds of our leaders and delegates…to select a man whose first duty will be to bring peace, harmony and Christian fellowship within our fold.

Forty years ago we had only a few men who were prepared for leadership but that is not true today. Every year God is bringing forth some young men with great ability, vision and with a Christ-like spirit which is surprising to many of us.

As a leader of the young Baptists of our convention, I am praying that a noble example will be set for these young people who will inherit the quality and spirit of those who served before them.

I have been in the convention for over 57 years and my policy has always been to help men rather than to destroy them. We have a great responsibility a great challenge and a great God who is able to guide us through this crisis into a great day of achievement if we allow nothing to separate us from His divine purpose and plan.[84]

The victory went to Joseph H. Jackson. He was installed as NBC's national president. Jackson had been known to oppose the tactics of Martin Luther King. He preferred more conservative methods to obtain civil rights. In September 1958, King was elected vice-president of the National Sunday School. The influence of the National Sunday School paralleled the power of Jackson as NBC president. The antagonism between the two ideological factions bubbled over in 1961, resulting in the split between NBC and newly formed Progressive NBC. Jernagin would have been disappointed with the fracture. His March 1957 address implored the NBC to realize that "the cause" was greater than any one person. This coded language meant the faith of Christ and the fight for civil rights.

In June 1957, Jernagin delivered his last annual address as president of the National Sunday School and BTU Congress. He recounted his trip to West Africa to attend the inaugural program of Kwame Nkrumah. He represented the NBC, Baptist World Alliance, National Council of Churches and NFCNC:

> *All honor must go to Premier Nkrumah for the leadership that he furnished, not only in the tribes of Gold Coast but also among the tribes of Shanghai. He was able to go beyond the chiefs, something never known to be done before, and organized the common folk. Hence, he had the largest political part in West Africa and therefore brought freedom to his people, the first independent government in the history of Africa since the beginning of the colonial law. What was done in Ghana can be done in Alabama, Louisiana, Mississippi and other states of our union or freedom of our people.*[85]

He delivered a charge to the National Sunday School community and told its members that their Christian duty extended beyond the walls of the church into the society to root out injustice and pursue equality:

> *The Christian church must not forget that democracy is rooted in the Christian faith as fostered by the great Protestant churches. The [church] must take the lead in influencing and shaping the new world community in harmony with the law and will of God. They must take the lead in the Battle for freedom and human rights. They must take the lead in defending the sacredness of the human person and the giving and securing of human rights, with emphasis on human instead of race color or nationality. They must do it under God; they must do it in self-defense.*
>
> *I thank God for the ministers He has given us for this new age—men like Doctors Martin Luther King, Jr., C.K. Steel, Ralph D. Abernathy, F.L. Shuttlesworth, William Holmes Borders, A.F. Fisher and others, who were not afraid to go to prison.*
>
> *[In May, the Pilgrimage of Prayer awakened] this sleeping nation, [to its] responsibility of leadership to a new world community, in goodwill toward men in justice, freedom and fair play to all men… The Negro does not want what is yours by inherent right and native ability, we only want the right to have the equality of what you have if we can merit it.*
>
> *For 75 years He has walked with me. I have found out that God's delay is not helplessness, but purposefulness. His patience is the handmaiden of*

grace. His silence is the bridle-reins of his mercy holding back the day
of judgement. He is coming and He will bring justice with Him. Do not
become discouraged; Do not falter; keep marching, keep praying; keep on
fighting in God's name.[86]

On November 2, 1957, a statement Jernagin issued on his eighty-eighth
birthday was published in the *Norfolk Journal and Guide*. The statement
reiterated his call for peace and freedom. Mankind must have freedom to
enjoy fellowship with one another. The article stated, "For the past 65 years
I have spoken from the public platform lending my voice and efforts to the
cause of freedom for all men throughout the world. I have preached for
many years that freedom is the vital factor which contradicts [materialism]."
He closed with an appeal to the youth to consider their role in the civil rights
struggle because freedom is their future.

TO A FRIEND, WE SAY, GOODNIGHT

Jernagin welcomed the New Year in January 1958. Aging and periodically
slower, he continued to maintain his dietary and exercise habits. His
schedule, the normal constellation of local, regional and national events,
was being contemplated until February 18, when death claimed him while
in Miami, Florida, on vacation. Shock and disbelief spread throughout
the city of Washington, the National Sunday School and NBC. The black
press reported that Jernagin was strong to the end. His life was fueled by
his capacity to care for and help people. One reporter stated, "He lived a
youthful life only God knows the amount of good he did." According to
Mount Carmel literature, he was a Christian for seventy-five years, a pastor
of nine churches over sixty-five years and president of the National Sunday
School for thirty-two years. His ministerial career achieved world renown as
a Christian missionary, statesman, educator and journalist.

He was a farsighted man who viewed new ideas and new groups as
beneficial. In 1915, he organized the Junior Deacon Board. In 1918, he
hired a professional social worker. He orchestrated Youth Week, expanding
the designated Youth Sunday of the NBC. In 1922, summer Bible school
opened along with junior church. Also in 1922, he opened a First Aid Club
and free clinic staffed with volunteer medical professionals. The cause of
healthcare extended into medical health and unemployment. To stem the

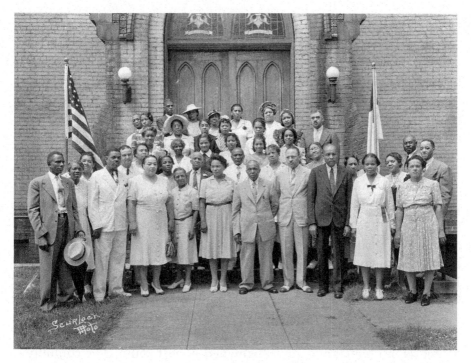

Cordelia Jernagin (front row, fourth from left), Jernagin (front row, seventh from left) and the Mount Carmel Social Action Committee. *MCBCA.*

tide of those twin evils, he started the Social Action Committee, which eased the pain of aging, poverty and household stress for the church and larger community. He promoted education and offered opportunities for both adults and children to continue their education. During his pastorate, 3,625 people joined Mount Carmel. They acknowledged that the world was his pulpit but Mount Carmel was his heart.

His funeral service spilled into the streets. The church was overflowing, and mourners moved across the street to Second Baptist Church. Dr. Pointer recalled there being an audio player broadcasting the more than thirty eulogies offered at Jernagin's funeral. His son Andrew Fowler presided, and his brother Ernest Estell offered expressions of sympathy on behalf of the National Sunday School and Baptist Training Union. The *Baltimore Afro-American* reported, "A positive leader [is] one who takes a firm stand and does not equivocate. For years [Jernagin] has been recognized as the 'watchdog of the race' at the Nation's capital, both as a race leader and a denominational leader."

Statements from a variety of prominent mourners were published. Mordecai Johnson said that Jernagin's death was a loss to Christianity

all over the world, as his heart was full of love for all kinds of human beings. Martin Luther King noted, "[Jernagin] has given to the Baptist youth of America a leadership which will long be recorded in the annals of history. He has inspired thousands of young men and women. I will always remember the encouragement that he has given me." E. Pauline Myers recalled, "There was no vain gloriousness about him. The common people loved him for he was one of them himself." Andrew Fowler remarked, "I am deeply saddened at [his passing]. He was the greatest champion of active righteousness."

In October 1958, King issued a statement in favor of a memorial to Jernagin. He wrote, "The idea of memorializing [Jernagin] deserves our brightest consideration. His commitment to the Christian ideal of love and brotherhood, his sane and wise judgement and his prophetic vision should be a lasting challenge to generations yet unborn." In 1959, Jernagin Memorial Sunday was planned by the Jernagin Memorial Committee. It selected October 11 as a national day of remembrance for all National Sunday School– and Baptist Training Union–affiliated churches. Jernagin's leadership was matchless, inspired and uplifting. Moreover, it resulted in many enlightened Baptist youth. The committee chairman was L. Venchael Booth.

Jernagin lived a life dedicated to service, his faith and his fight for civil rights. He did not see the two ideas separate; he saw them as a means to an end. He heard stories of injustice, experienced discrimination and crusaded to raise the issue with intentions to drive out the sin in the land. Segregation hurt blacks and whites, denying the full expression of divinely implanted, humanly expressed ideas and progress for mutual benefit. Moreover, it hurt the heart of God because in Him there is no color or injustice. In his book *Christ at the Battlefront*, he wrote that there can be no peace in the world if "the Prince of Peace is ignored at the peace tables. God must be placed at the center of our civilization, if not destruction awaits us. The only adequate gospel for our confused age, is one which puts God back to the center of living. Except the Lord build the house, they labor in vain that build it; except the Lord keep the city, the watchman waketh but in vain."

He lived his life in pursuit of the Lord's will for mankind, racial reconciliation and civil rights. He mentored and inspired youth across the country to seek divine relationship, guidance and discipline in Jesus Christ. This example of fighting faith continues to inspire and challenge rising generations nationally and worldwide.

WILLIAM HENRY
JERNAGIN TIMELINE

October 13, 1869	Born in Mashulaville, Mississippi, to Allen and Julia Ruth Jernagin.
1880–87	Educated in public schools of Noxubee and Lauderdale Counties in Mississippi. He attended Meridian Academy, Alcorn A&M College and Jackson College. He also attended American Correspondence School in Danville, New York.
1882	Converted to Christianity and joined the Baptist Church.
1885–86	Became superintendent of Sunday school in Pine Grove Baptist Church, Bailey, Mississippi.
1886?	Taught for five years in Lauderdale, Mississippi.
October 15, 1888	Married Willie Stennis of Mississippi. She was educated at Meridian and worked as a teacher. They had four daughters: Lottie (1889), Rosa B. (1890), Mattie (1892) and Gertrude (1897).
1890	Licensed to preach by the Bush Fork Baptist Church in Mississippi.

1892	Ordained to preach and selected as pastor for New Prospect Baptist Church in Meridian, followed by Mount Moriah Baptist Church.
1896	Pastored Scooba Baptist Church in Okolona, where he united Missionary Union Baptist Church and Second Baptist Church. Followed by First Baptist Church in Winona, Mississippi; First Baptist Church in Mound Bayou, Mississippi; First Baptist Church in Brandon, Mississippi; and Tabernacle Baptist Church in Oklahoma City, Oklahoma.
	Founded Meridian Baptist Seminary in Mississippi.
	Organized the Young People's Christian Educational Congress of Mississippi. He became president of the Oklahoma General Baptist Convention. He served as business manager for Alcorn College in Lorman, Mississippi. He was instrumental in establishing the Winona-Grenada Baptist College.
1899–1905	Elected president of the Mississippi BYPU Convention and the first to be organized under the National Baptist Convention.
	Left Mississippi for Oklahoma, accepting the pastorate of Tabernacle Baptist Church in Oklahoma City.
1907	Participated in an early civil rights protest against Jim Crow in Oklahoma.
1908	Awarded honorary doctor of divinity degree from Guadalupe College, Seguin, Texas. The original degree is in the archives at Mount Carmel.
1912–58	Appointed to Mount Carmel Baptist in Washington, D.C., where he served until his death. From the Mount Carmel pulpit, he built a nationwide career.
1916	Elected first president of the National Race Congress.
	Elected vice-president at large to the National Sunday School and the BTU Congress.

1919	Traveled to Paris, France, with the committee of Federal Conference Churches for Christ. Attended the Pan-African Congress as a representative. While in Europe, he attended the Peace Conference post–World War I.
1920	Served on the board of directors for Frelinghuysen University, a school founded by Anna Julia Cooper.
	Spent six weeks touring camps and speaking to black World War I soldiers.
1921	Toured London, Paris, Rome and Brussels, making a study of the social education and welfare of African Americans in Europe.
	Hosted President Charles Dunbar Burgess King of Liberia.
1926	Founded Washington Baptist Seminary, Washington, D.C. The school opened teaching classes at Second Baptist Church on Third Street between H and I Streets, NW, for thirteen years. Mount Carmel also served as a campus.
	Implemented a new diet plan espoused by Dr. St. Louis Estes. He cut his weight from 210 to 150 pounds.
1928	Voted world's oldest youth leader at fifty-nine years old.
	Elected president of the Consolidated National Equal Rights League and Race Congress.
1932	Attended the Republican National Convention in Chicago as a delegate.
1934	Traveled to the Holy Land after serving as a delegate of the Baptist World Alliance.
	Traveled to Berlin, Germany, as a delegate of the Baptist World Alliance
1937	Traveled to Zurich, Switzerland, to attend the World's Youth Conference as a chaperone. This was a Baptist World Alliance affiliate organization. He served as a key speaker at the conference. The American delegation was given tours in England and Germany.

	Elected president of the National Fraternal Council of Negro Churches.
1940	Organized the Washington Bureau of the National Fraternal Council of Negro Churches.
1942	Appointed a civilian chaplain. Toured the Pacific theater for the Defense Department on behalf of racial justice.
	Willie Stennis Jernagin died.
1943–44	Successfully sued Southern Railway.
1945	Married Cordelia Woolfolk.
1945–55	Only Negro member of the Baptist World Alliance executive board.
1947	Traveled to Copenhagen, Denmark, to address the Baptist World Alliance.
	Awarded President's Certificate of Merit in recognition of outstanding service for the Fraternal Council of Churches.
May 1947	Awarded certificate from the United Negro and Allied Veterans of America (UNAVA).
1948	Served as a delegate of the National Baptist Convention in Europe to help organize the World Council of Churches. As a member of the constitution committee, he fought spiritually and faithfully to see that there were no laws of segregation in this world religious organization.
1949	Awarded an honorary doctor of divinity degree from Simmons University, Louisville, Kentucky.
October 22, 1949	Published two articles—"Watch Your Stomach" and "Take Care of Your Stomach and Your Stomach Will Take Care of You"—focused on healthy eating and exercise.
1950	Attended the Foreign Mission Board of the National Baptist Convention, Incorporated. An extensive tour was arranged for him. He visited stations of foreign missions on the west coast of Africa, as well as the interior countries. He visited Lagos, Algeria, Gold Coast, Ivory Coast, Liberia, Sierra Leone and Dakar.

1951	Awarded an honorary doctor of divinity degree from Howard University, Washington, D.C.
1953	Served as chief of chaplains for the U.S. Air Force along with sixteen other American ministers. They traveled thirty-five thousand miles by plane, jeep and boat to locations such as Honolulu, Tokyo, Okinawa, Korea, Guam and Manila, addressing about fifty thousand men.
April 5, 1953	Delivered Easter evening service message within eight miles of the Korean combat zone. His travels inspired him to author *Christ at the Battlefront*.
	Attended the signing of civil rights legislation at the White House with President Harry S Truman.
1954	Organized and attended the Thanksgiving Prayer Pilgrimage to Lincoln Memorial.
1955	Joined Mary Church Terrell in protesting discrimination at Thompson's Restaurant.
1957	Awarded clergyman of the year and honorary life membership certificates by Washington Pilgrimage with Billy Graham.
	Participated with the President Dwight D. Eisenhower administration to secure human and civil rights along with other early civil rights leaders and church men.
February 18, 1958	Died of gallbladder obstruction in Miami, Florida.
February 25, 1958	Buried at Lincoln Cemetery. His funeral service was three hours and fifteen minutes long. There were thirty speakers. He served for forty-six years at Mount Carmel, sixty-five years as a watchman, seventy-five years embracing hope in Christ and eighty-five years on these mundane shores.
October 1958	Martin Luther King Jr. proposed a memorial for Jernagin.

Jernagin held membership in:
Mason
Odd Fellows
Knights of Pythias

Eastern Star
St. Luke's Mosaics
Elks
Moses and Supreme Order of Helpers
Republican Party
National Baptist Convention
BYPU
Baptist World Alliance

NOTES

PREFACE

1. *The Nation's Prayer Call* 2, no. 6 (November–December 1957), general writings, Mount Carmel Baptist Church Archives (MCBCA).
2. PNBC website.
3. Letter to Bishop W.J. Walls, January 17, 1957, from Jernagin correspondence, MCBCA.
4. "On the Matter of Christianity and World Tensions," 1957, Jernagin writings, MCBCA.
5. *The Nation's Prayer Call* 2, no. 6 (November–December 1957).

CHAPTER 1

6. *Encyclopedia of Oklahoma.*
7. Span, "I Must Learn Now or Not at All," 197.
8. Ibid., 198.
9. Ibid.
10. Ibid., 202.
11. Kansas Historical Society, "Exodusters."
12. Littlefield and Underhill, "Black Dreams and 'Free' Homes," 342.
13. Tolson, "Black Towns of Oklahoma," 20.
14. Ibid., 22.

15. News clippings, WHJ career, Constitutional League, MCBCA.
16. *Guinn and Beal v. United States*.
17. Ibid.

CHAPTER 2

18. News clippings, WHJ career, "Aggressive or Perish," MCBCA.
19. Wormer, *Rise and Fall of Jim Crow*.
20. Mount Vernon Triangle, "History."
21. News clippings, WHJ career, "Mount Carmel Draws Big Crowds," MCBCA.
22. Statement made by Miss Burroughs at the close of her annual report to Women's Convention, held in St. Louis, 1938, Nannie Helen Burroughs Papers, Library of Congress.
23. Introduction of Jernagin by Burroughs, undated, Nannie Helen Burroughs Papers, Library of Congress.
24. Puttkammer and Worthy, "William Monroe Trotter," 303.
25. Ibid., 305.
26. Lunardini, "Standing Firm," 247–48.
27. Garrett, *The President and the Negro*, 261.

CHAPTER 3

28. Miller, *Kelly Miller's History*, 443.
29. Chase, "Shelling the Citadel of Race Prejudice," 371.
30. Love, "Role of the Church," 502–3.
31. Ibid., 503.
32. Ibid., 504.
33. Ibid.
34. Kerlin, *Negro's Reaction to the World War*, 8.
35. Miller, *Kelly Miller's History*, 478.
36. Kerlin, *Voice of the Negro*, 48.
37. Adejumobi, "Pan-African Congress," 549.
38. Ibid., 550.

CHAPTER 4

39. Clark-Lewis, *First Freed*, xv.
40. Emancipation celebration address, "New Freedom," January 1, 1934, Jernagin writings, MCBCA.
41. Ibid.
42. Ibid.
43. Ibid.
44. Courtland Milloy, "Emancipation Day's Unsung Champion," *Washington Post*, April 16, 2006.
45. Sawyer, "Fraternal Council of Negro Churches," 52.
46. Bynum, "An Equal Chance in the Race for Life," 4.
47. Sawyer, "Fraternal Council of Negro Churches," 53.
48. Ibid., 56.
49. Ibid., 59.
50. Ibid., 61.
51. "A Prayer to Be Prayed, January 7, 1948, by the Ministers Representing the Fraternal Council of Negro Churches," general writings, MCBCA.
52. "Address by Rev. Dr. Martin Luther King Jr.," May 17, 1957, general writings, MCBCA.
53. E. Pauline Myers, "Pamphlet Hands Across the Table," general writings, MCBCA.
54. Ibid.
55. Ibid.
56. Ibid.
57. Ibid.
58. Letter to Jernagin from Martin Luther King Jr., July 12, 1957, Jernagin correspondence, MCBCA.
59. Fowler, "What Kind of Man Is This?" 37–38.
60. Letter from Jernagin to Congressman John S. Wood, June 11, 1951, Jernagin writings, MCBCA.
61. Kelly Miller, "Emerging Women," unpublished essay.
62. McCluskey, "Setting the Standard," 51.
63. Ibid., 52.
64. Ibid.
65. Ibid., 53.
66. Love, "Role of the Church," 507.
67. Ibid., 509.
68. Jernagin, *Christ at the Battlefront*.
69. Ibid.

70. Ibid.
71. Ibid.

CHAPTER 5

72. Guadalupe College history notes, Cushing Library and Archives at Texas A&M University, Guadalupe College Collection.
73. Ibid.
74. Letter to James Nabrit from Jernagin, April 27, 1951, Jernagin correspondence, MCBCA.
75. "Our Pastor," biographical narrative, Jernagin biographical material, MCBCA.
76. Ibid.
77. "The Funeral of Dr. W.H. Jernagin," writings about Jernagin, MCBCA.
78. Bergler, *Juvenilization of American Christianity*, 4.
79. Ibid., 98.
80. Letter to Jernagin from Gardner Taylor, correspondence, MCBCA.
81. Taylor, "Reflections."
82. Fowler, "What Matter of Man Is This," 50.
83. "Release: To the Baptist Constituency of the National Baptist Convention, Inc.," Jernagin writings, MCBCA.
84. Ibid.
85. "The Annual Address of Dr. W.H. Jernagin," Dallas, Texas, June 20, 1957, Jernagin writings, MCBCA.
86. Ibid.

BIBLIOGRAPHY

Adejumobi, Saheed. "Pan-African Congress." In *Organizing Black America: An Encyclopedia of African American Associations*. Edited by Nina Mjagkij. New York: Garland Publishing, Inc., 2001.

Bergler, Thomas E. *The Juvenilization of American Christianity*. Grand Rapids, MI: William B. Eerdman's Publishing Company, 2012.

Brophy, Alfred L. *Guinn v. United States* (1915).

Bynum, Cornelius L. "'An Equal Chance in the Race for Life': Reverdy C. Ransom, Socialism, and the Social Gospel Movement, 1890–1920." *Journal of African American History* 93, no. 1 (Winter 2008): 1–20.

Chase, Hal S. "Shelling the Citadel of Race Prejudice: William Calvin Chase and the Washington *Bee*, 1882–1921." *Records of the Columbia Historical Society* 49 (1973–74): 371–91.

Clark-Lewis, Elizabeth, ed. *First Freed: Washington, D.C. in the Emancipation Era*. Washington, D.C.: A.P. Foundation Press, 1998.

Contee, Clarence G. "DuBois, the NAACP, and the Pan-African Congress of 1919." *Journal of Negro History* 57, no. 1 (January 1972): 13–18.

Ellis, Mark. *Race, War, and Surveillance: African Americans and the United States Government during World War I*. Bloomington: Indiana University Press, 2001.

Encyclopedia of Oklahoma History and Culture. N.p., n.d.

Fowler, John. "What Kind of Man Is This? The Life and Times of Andrew Fowler." Howard University Department of History, Howard University, Washington, D.C. Unpublished seminar paper, 2014.

Garrett, Romeo B. *The President and the Negro*. Peoria, IL: Bradley University, 1982.

Guinn and Beal v. United States, 238 U.S. 347. Supreme Court, June 21, 1915.

Holtzclaw, Robert Fulton. *Black Magnolias: Brief History of the Afro-Mississippian, 1865–1980*. Shaker Heights, OH: Keeble Press, 1989.

Jernagin, William H. *Christ at the Battlefront: Servicemen Accept the Challenge*. Washington, D.C.: Murray Brothers, 1946.

Kerlin, Robert. *The Negro's Reaction to the World War*. Norfolk, VA, 1920.

———. *The Voice of the Negro 1919*. New York: Arno Press, 1968.

Littlefield, Daniel F., and Lonnie E. Underhill. "Black Dreams and 'Free' Homes: The Oklahoma Territory, 1891–1894." *Phylon* 34, no. 4 (1973): 342–57.

Love, Edgar. "The Role of the Church in Maintaining the Morale of the Negro in World War I and II." *Journal of Negro Education* 12, no. 3 (Summer 1943): 502–10.

Lunardini, Christine A. "Standing Firm: Wm Monroe Trotter's Meetings with Woodrow Wilson, 1913–1914." *Journal of Negro History* 64, no. 3 (Summer 1979): 244–64.

McCluskey, Audrey Thomas. "Setting the Standard: Mary Church Terrell's Last Campaign for Social Justice." *The Black Scholar* 29, no. 2–3 (Summer–Fall 1999): 47–53.

McMillen, Neil R. *Dark Journey: Black Mississippians in the Age of Jim Crow*. Chicago: University of Illinois, 1989.

Miller, Kelly. *Kelly Miller's History of the World War for Human Rights; Being an Intensely Human and Brilliant Account of the World War, and Why and for What Purpose America and the Allies Are Fighting, and the Important Part Taken by the Negro, Including the Horrors and Wonders of Modern Warfare, the New and Strange Devices, Etc.* Washington, D.C.: Austin Jenkins Co., 1919.

Moorehouse, Maggi M. "Black Citizen Solider." PhD dissertation, University of California–Berkeley, 2001.

Puttkammer, Charles W., and Ruth Worthy. "William Monroe Trotter, 1872–1934." *Journal of Negro History* 43, no. 4 (October 1958): 298–316.

Sawyer, Mary R. "The Fraternal Council of Negro Churches, 1934–1964." *Church History* 59, no. 1 (March 1990): 51–64.

Snape, Michael *God and Uncle Sam: Religion and America's Armed Forces in World War II*. Suffolk, UK: Boydell Press, 2015.

Span, Christopher M. "'I Must Learn Now or Not at All': Social and Cultural Capital in the Educational Initiatives of Formerly Enslaved African Americans in Mississippi, 1862–1869." *Journal of African American History* 87 (Spring 2002): 196–205.

Thompson, Patrick H. *The History of Negro Baptist in Mississippi.* Jackson, MI: R.W. Printing, 1898.

Tolson, Arthur L. "Black Towns of Oklahoma." *The Black Scholar* 1, no. 6 (April 1970): 18–22.

Wormer, Richard. *The Rise and Fall of Jim Crow.* PBS documentary.

Newspapers

Baltimore Afro-American
Chicago Defender
Kansas City Advocate
New York Times
Norfolk Journal and Guide
Oklahoma Safeguard
Washington Bee

Websites

Frank, Andrew K. "Trail of Tears." *Encyclopedia of Oklahoma History and Culture.* www.okhistory.org/publications/enc/entry.php?entry=TR003.

Kansas Historical Society. "Exodusters." www.kshs.org/kansapedia/exodusters/17162.

Mount Vernon Triangle, DC. "History." www.mountvernontriangle.org/resource-library/history.

Progressive National Baptist Convention, Inc. www.pnbc.org.

Taylor, Gardner C. "Reflections." National Ministries. www.nationalministries.org/front_center_taylor_90th_reflections.cfm.

INDEX

ABOUT THE AUTHOR

Ida E. Jones is the university archivist at Morgan State University. Her professional interests revolve around African American religious history and organizational histories/archives. She conducts workshops for organizations and groups interested in preserving their history. She is an enthusiastic supporter of biography and seeks to promote micro-biographies about forgotten, intriguing and impactful people whose lives enhanced others and sought to make the world better.

Visit us at
www.historypress.net
..
This title is also available as an e-book

CPSIA information can be obtained
at www.ICGtesting.com
Printed in the USA
LVOW13*1836120218
566218LV00017B/153/P